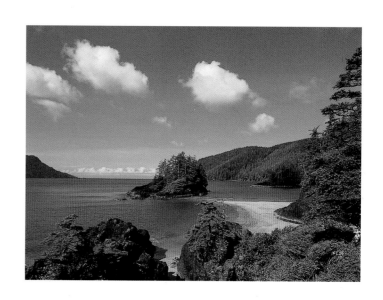

VANCOUVER
ISLAND

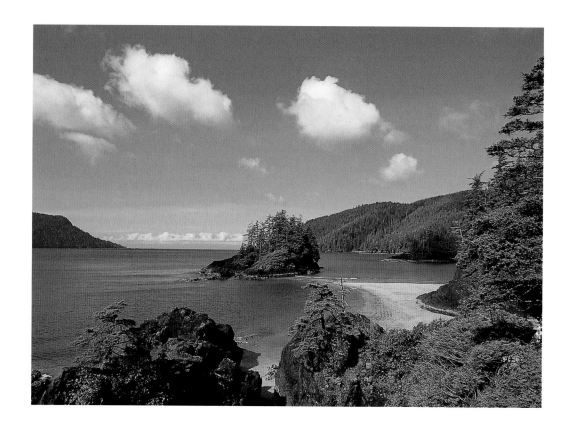

WHITECAP BOOKS
VANCOUVER / TORONTO

Text by Tanya Lloyd
Edited by Elaine Jones
Photo editing by Tanya Lloyd
Proofread by Lisa Collins
Cover and interior design by Steve Penner
Desktop publishing by Vivienne Wong
Printed and bound in Canada

Canadian Cataloguing in Publication Data

Lloyd, Tanya, 1973–
 Vancouver Island

 ISBN 1-55285-017-X

 1. Vancouver Island (B.C.)—Pictorial works. I. Title.
FC3844.4.L56 2000 971.1'204'0222 C00-911056-3
F1089.V3L56 2000

The publisher acknowledges the support of the Canada Council and the Cultural
Services Branch of the Government of British Columbia in making this publication
possible. We acknowledge the financial support of the Government of Canada through
the Book Publishing Industry Development Program for our publishing activities.

**For more information on the Canada Series and other Whitecap Books
titles, please visit our web site at www.whitecap.ca.**

In 1906, the *Valencia* sailed from San Francisco, bound for Victoria with 65 crew members and 108 passengers on board. In the fog, the ship missed the entrance to the Juan de Fuca Strait and was wrecked on the rocky coast just before midnight. Only 37 people survived. This sounds like a tale from the time of George Vancouver, when the coast was uncharted and sparsely populated. Yet, in the year the *Valencia* floundered, Victoria had been the provincial capital for 35 years, Jenny Butchart was at work transforming her family's quarry into the magnificent Butchart Gardens, and Nanaimo was a well-established and prosperous community.

This bold contrast between the ruthless powers of nature and the genteel attractions of civilization is still apparent today as one tours the sights and cities of Vancouver Island. While some visitors choose to take tea in the lobby of the Empress Hotel or gaze at the waves of Long Beach from the deck of a luxurious bed and breakfast, others strap on backpacks and tackle the gruelling West Coast Trail or hike towards the isolated reaches of Cape Scott. In many island harbours, small whale-watching vessels dock beside commercial fishing fleets. Kayakers are just as likely to see the old-growth forests of Clayoquot Sound as loggers are, and caving is growing as commonplace as mining was a century ago.

Vancouver Island offers 3,440 kilometres (2,150 miles) of coastline, a measurement roughly equal to the diameter of the moon. Each bay, beach, or community along these shores boasts a unique character. It is this diversity that draws some visitors back to the same treasured retreat year after year, while driving others to constantly seek the next adventure.

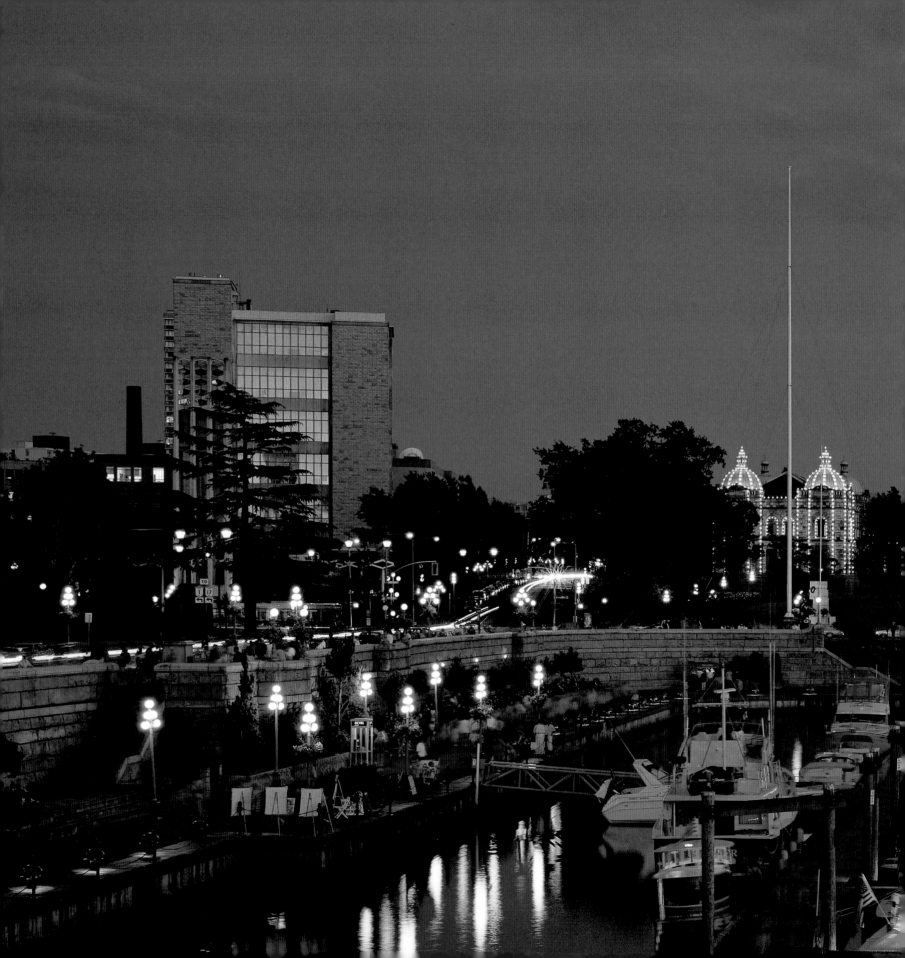

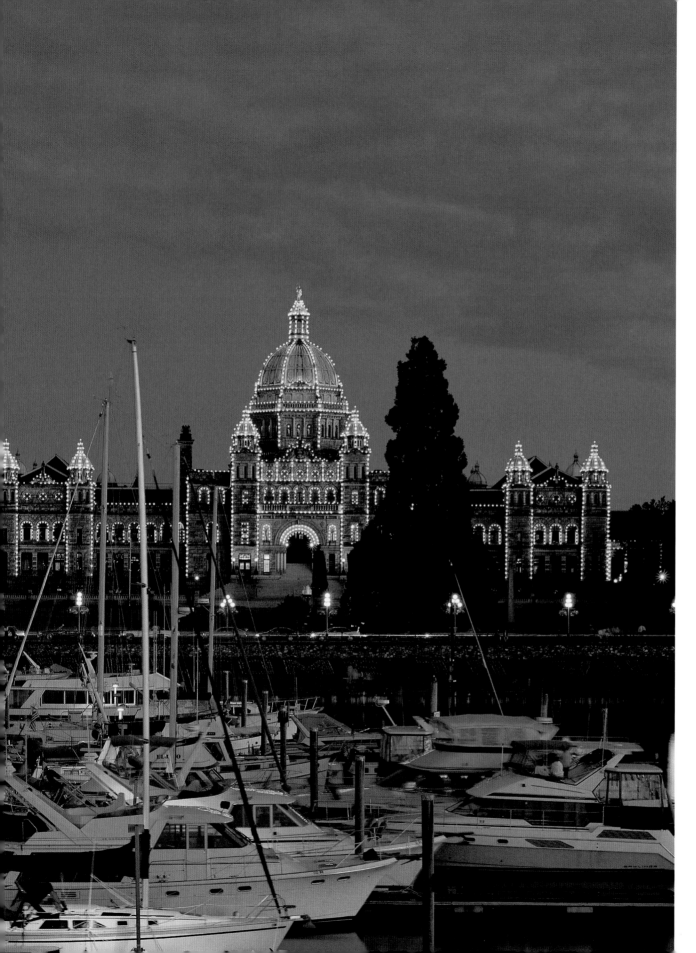

When James Douglas ordered the construction of a Hudson's Bay Company fort on the southern tip of Vancouver Island in 1843, he named it Fort Victoria. Queen Victoria had come to the throne in Britain only six years before.

7

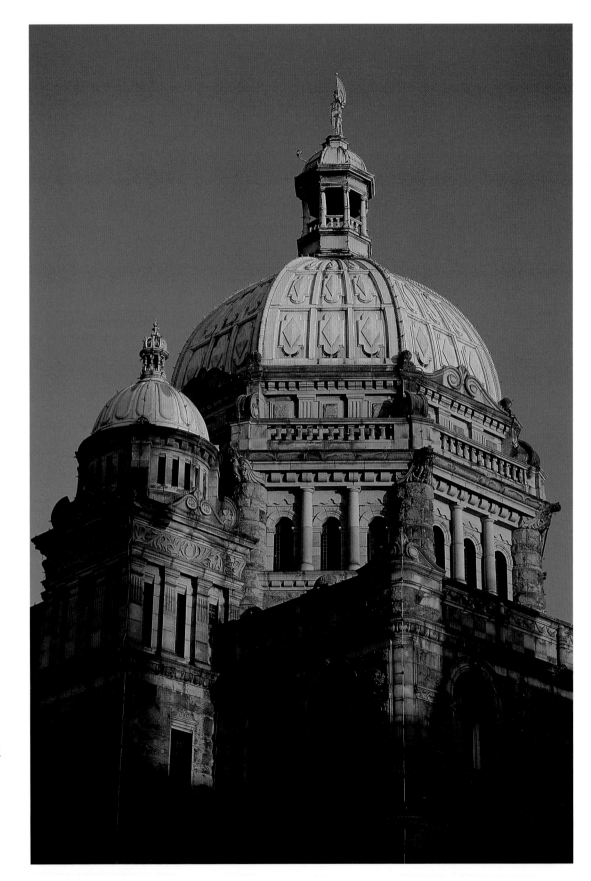

Officially opened in February 1898, the Legislative Buildings cost about a million dollars to build—an extravagant cost at the time—and replaced an earlier complex known as the "Birdcages."

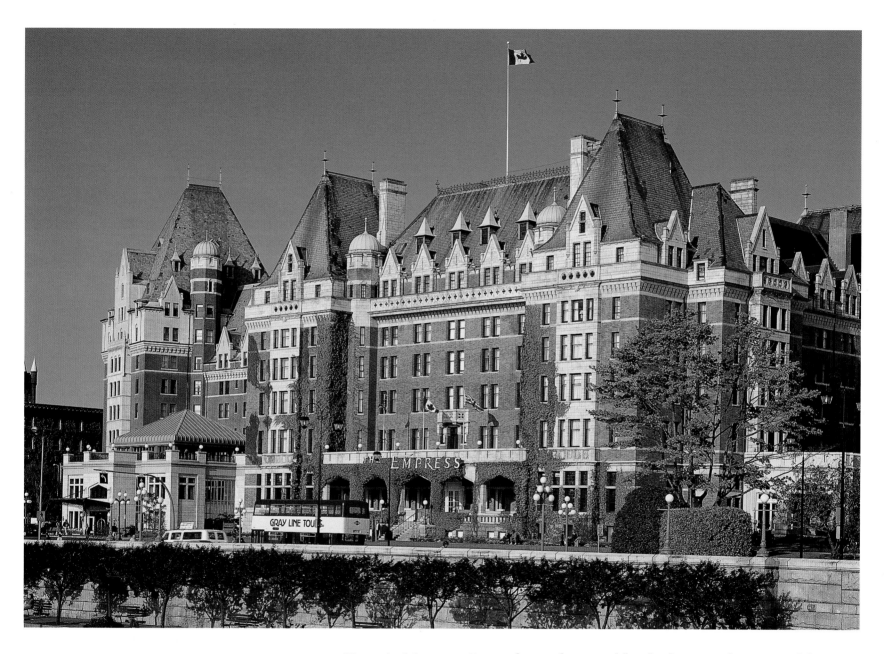

Francis Mawson Rattenbury designed both the Legislative Buildings and the Empress Hotel, which opened across the harbour in 1908. Tea at the stately hotel is a Victoria tradition and the Empress serves 750,000 cups annually.

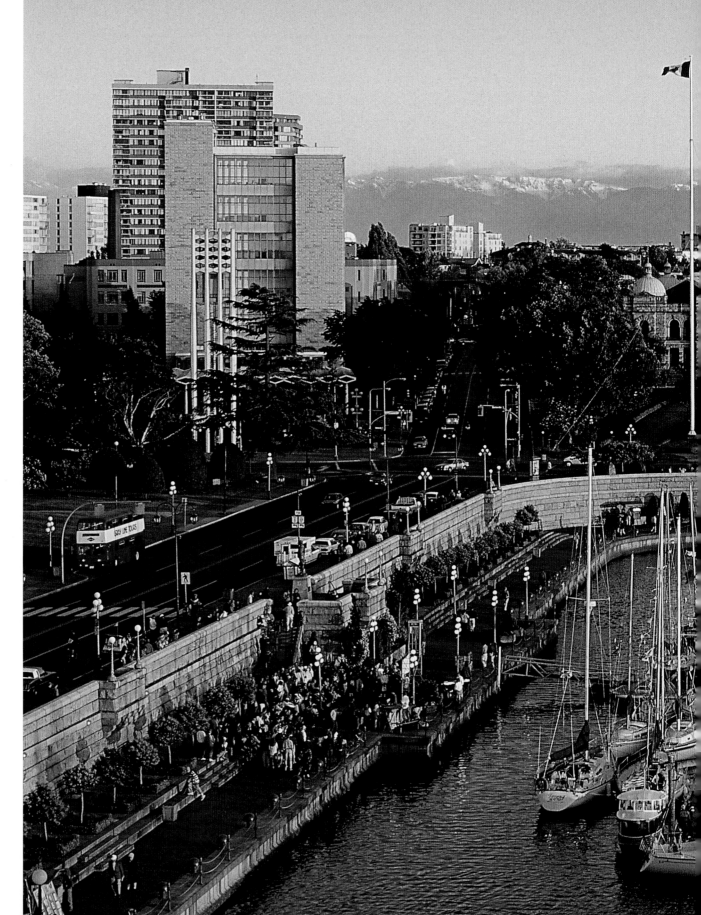

Yachts crowd the Inner Harbour just before the Swiftsure International Yacht Race, a sailing challenge attracting more than 200 boats each May. The event began in 1930, when six boats raced from Cadboro Bay around Swiftsure Bank at the entrance to Juan de Fuca Strait.

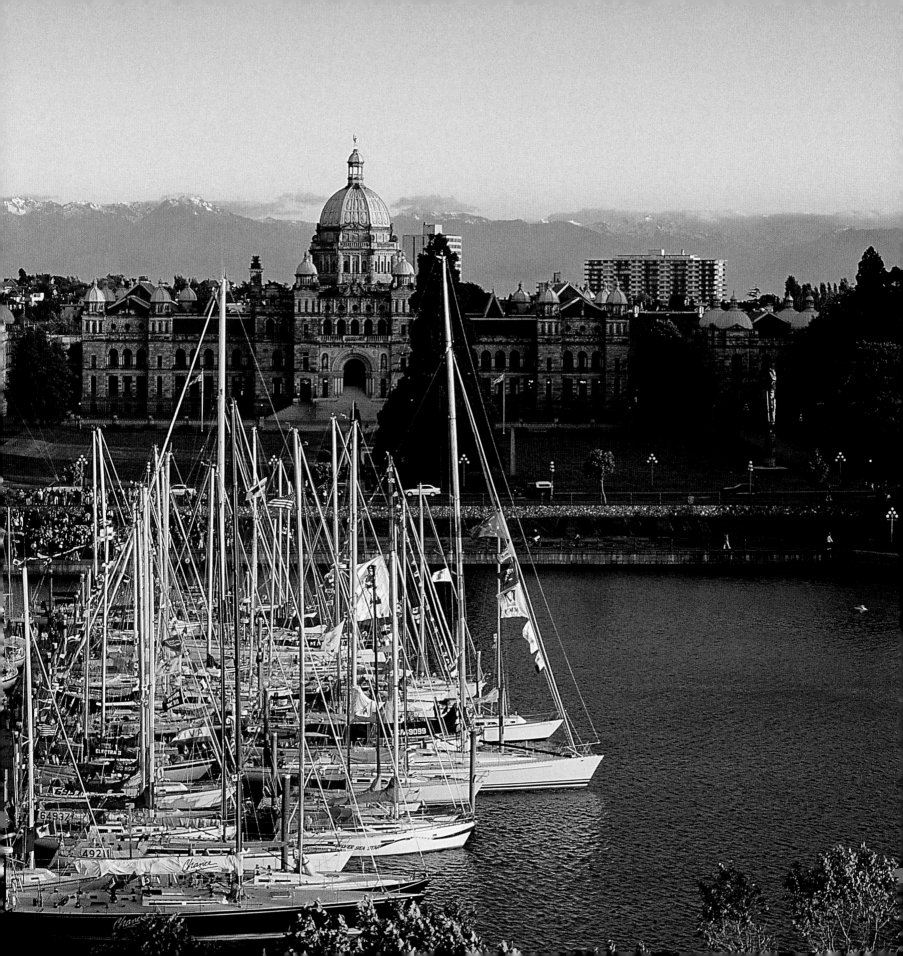

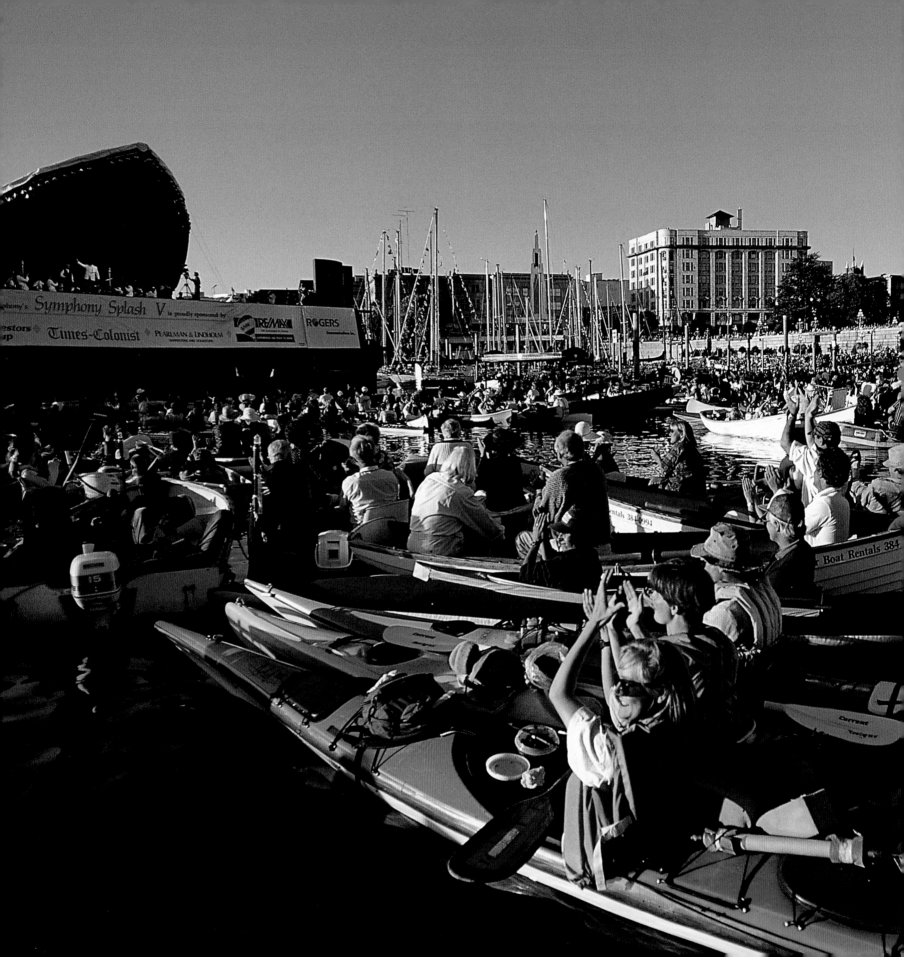

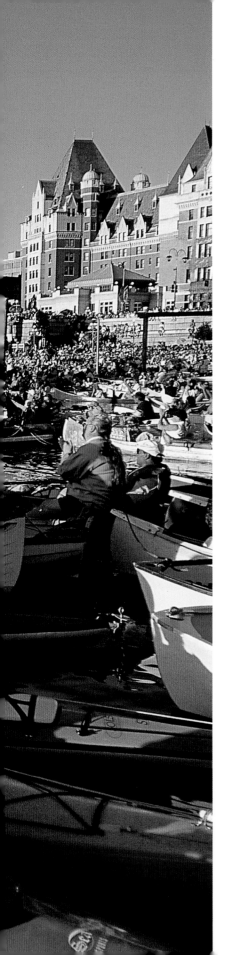

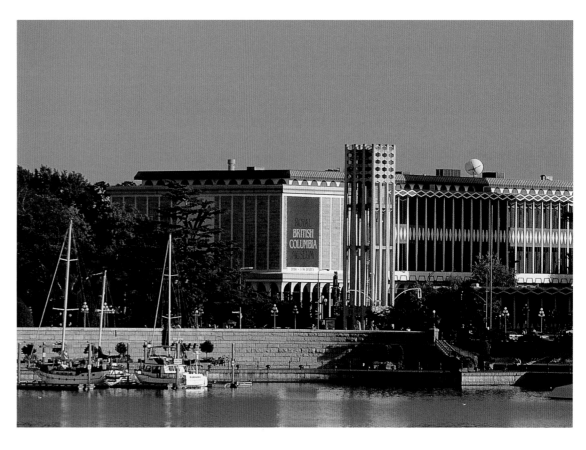

Visitors to the Royal British Columbia Museum find themselves wandering from the ice age to the coastal rainforest, tracing human and natural development through centuries. The museum was established in 1886.

The Victoria Symphony Orchestra's best-known event is Symphony Splash, when thousands of guests gather to hear the orchestra perform an evening concert from a barge on the Inner Harbour.

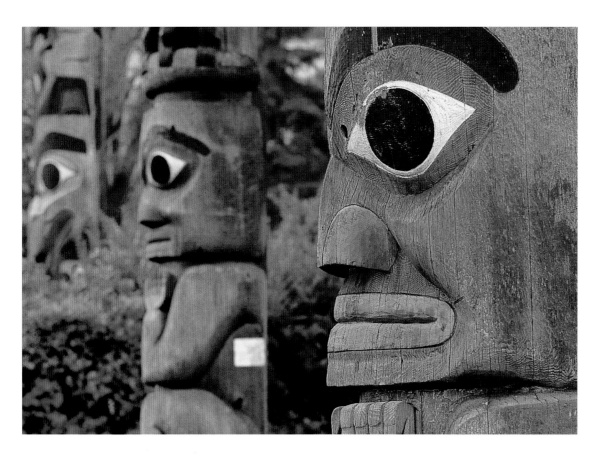

At Thunderbird Park, the Royal British Columbia Museum and the Victoria Native Friendship Centre work together to teach visitors about local First Nations culture through guided park tours and carving demonstrations.

Most Victoria residents are drawn to Fisherman's Wharf not for picturesque scenes of the harbour, but for dinner. Barb's Fish and Chips does a brisk business in newspaper-wrapped cod and french fries.

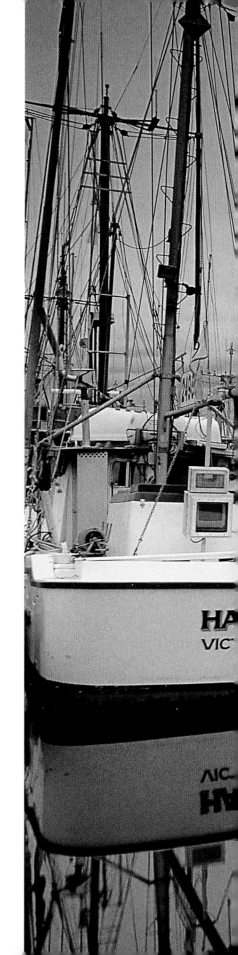

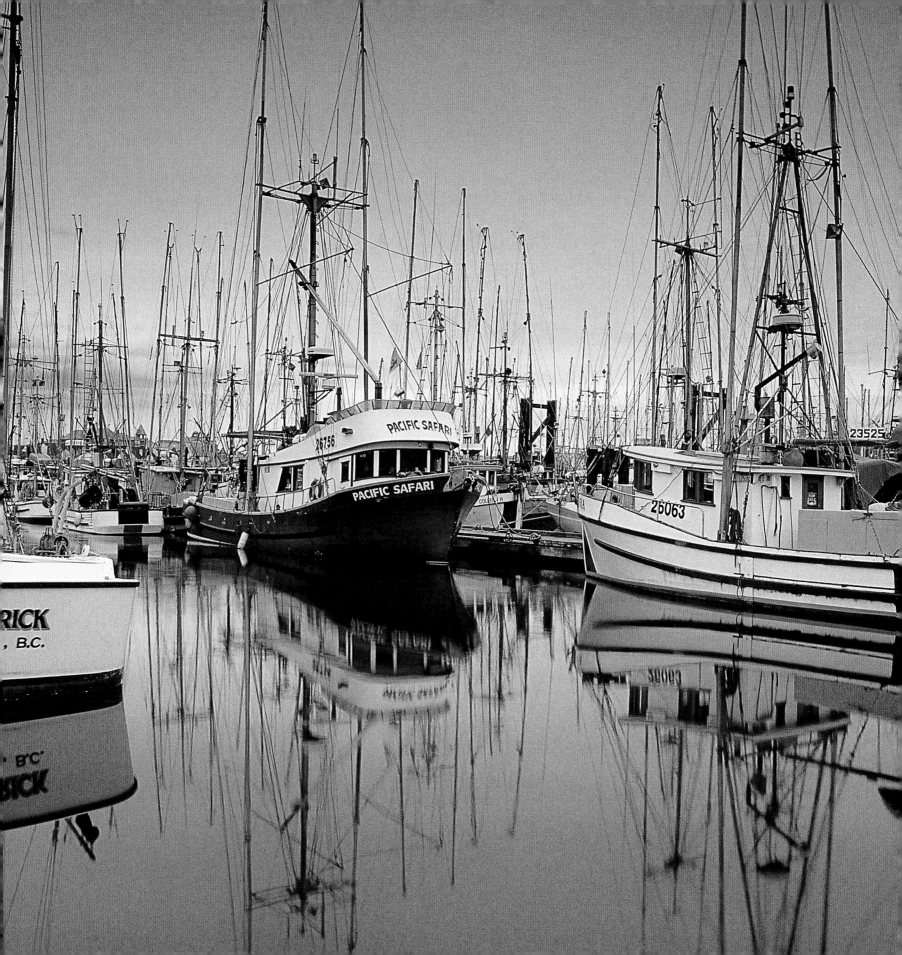

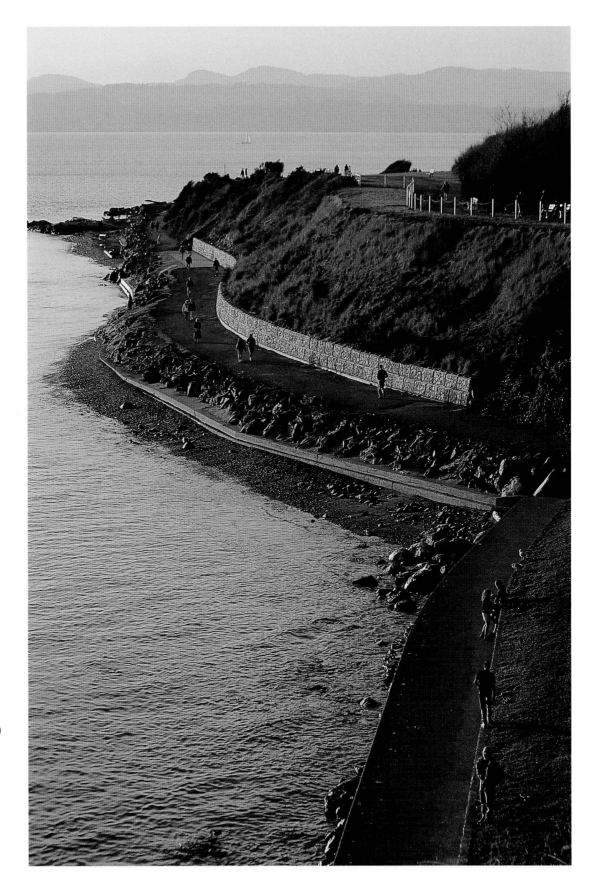

The 74 hectares (183 acres) of Beacon Hill Park combine beaches and rocky bluffs with secluded ponds and manicured gardens.

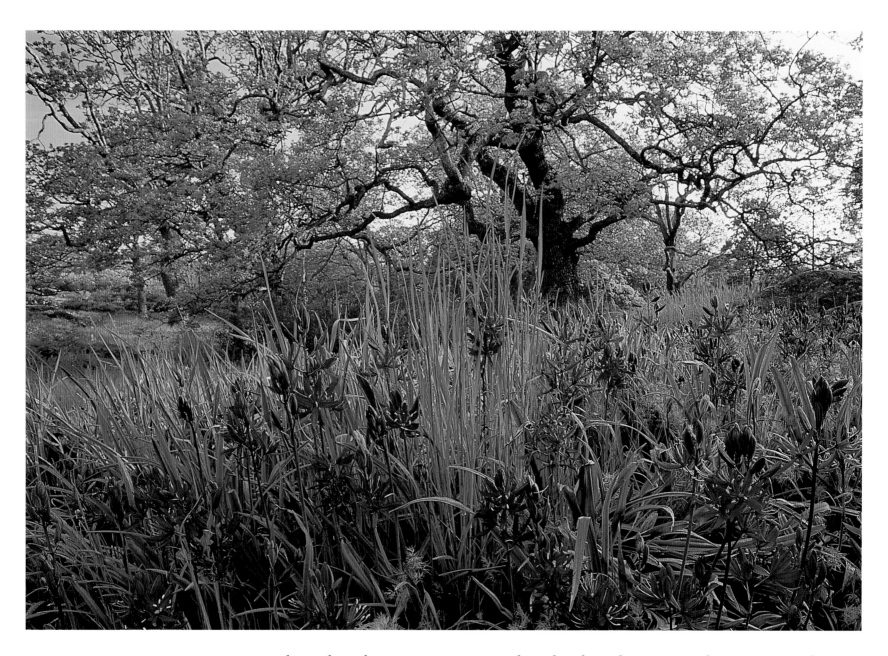

The only oak tree native to British Columbia, the Garry oak is increasingly threatened by pests and urban development. Those that remain on Vancouver Island are fiercely protected by a number of local conservation groups. The oak shown here is safely within the boundaries of Beacon Hill Park.

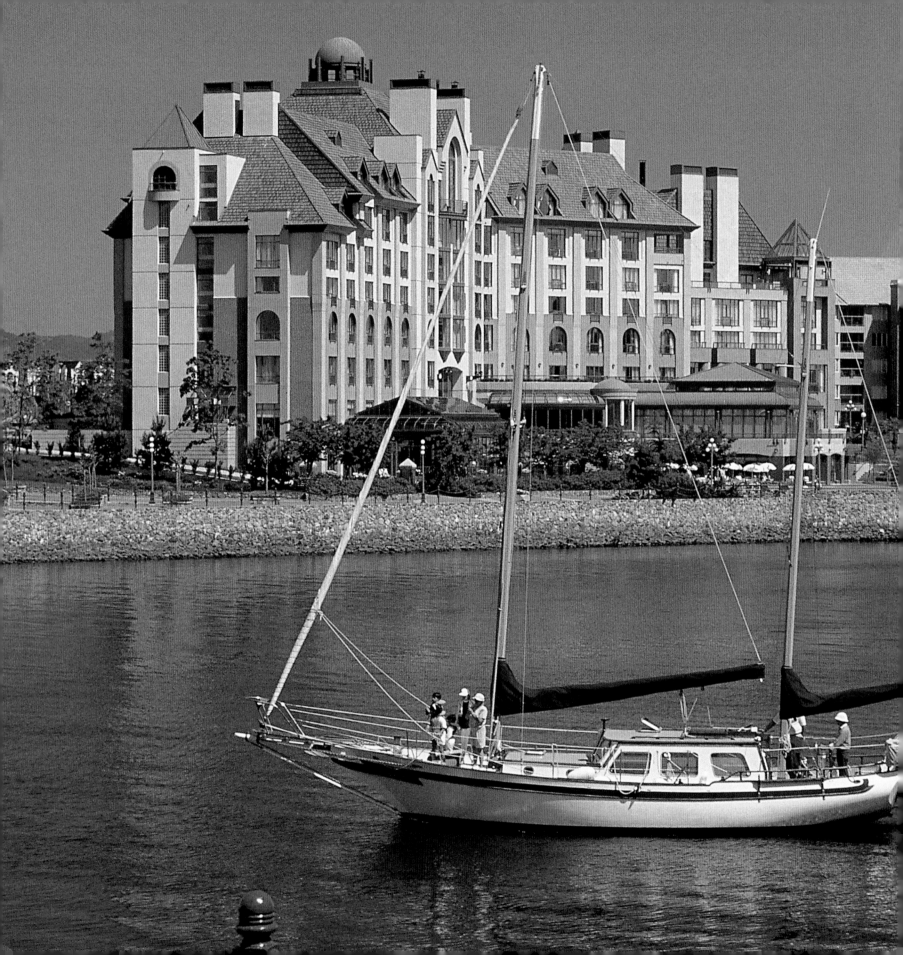

Victoria basks in its reputation as the City of Gardens. During the flower count held each February, residents count the blossoms in their neighbourhoods and call in the results. The total has reached over 1.6 billion.

The Ocean Pointe Resort Hotel and Spa overlooks the Inner Harbour and the Juan de Fuca Strait. Guests can enjoy a massage, play a game of tennis, or catch a water taxi to downtown Victoria.

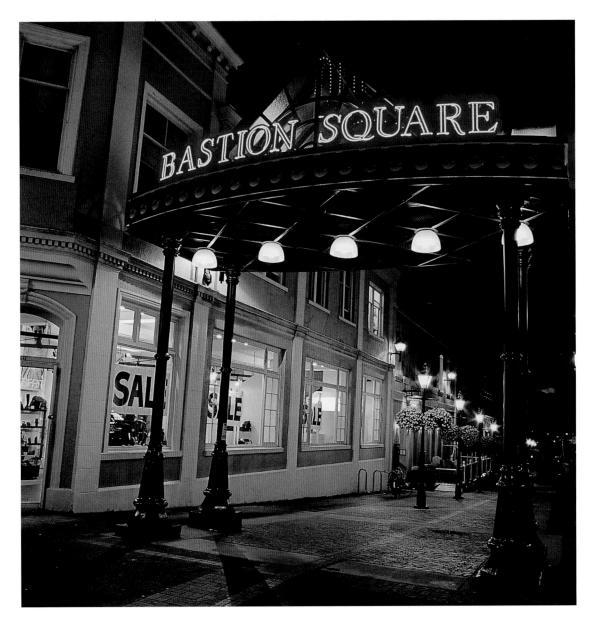

The wooden walls of Fort Victoria once stood at today's Bastion Square. The palisade was torn down in the 1860s and the square is now home to cafés, galleries, and specialty shops.

Built as a private residence for coal baron Robert Dunsmuir, who died before the mansion was complete, Craigdarroch Castle has since served as a hospital, a college, an office building, a conservatory, and, most recently, a museum.

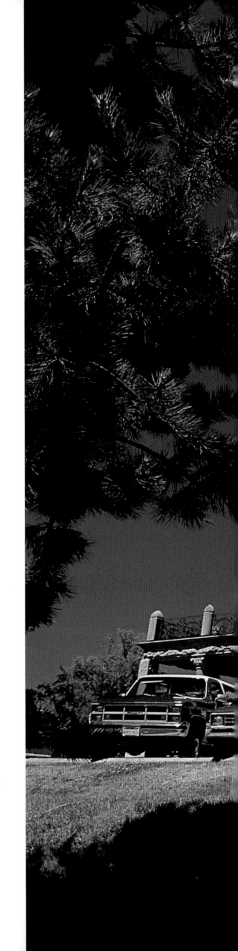

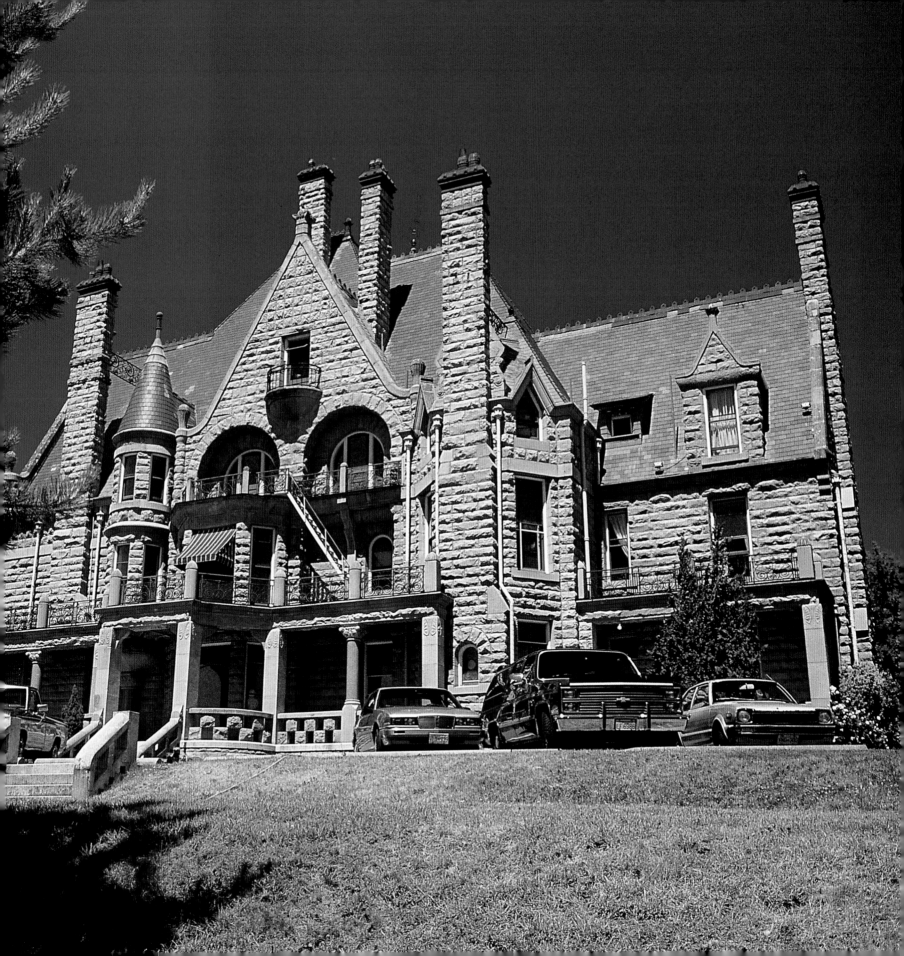

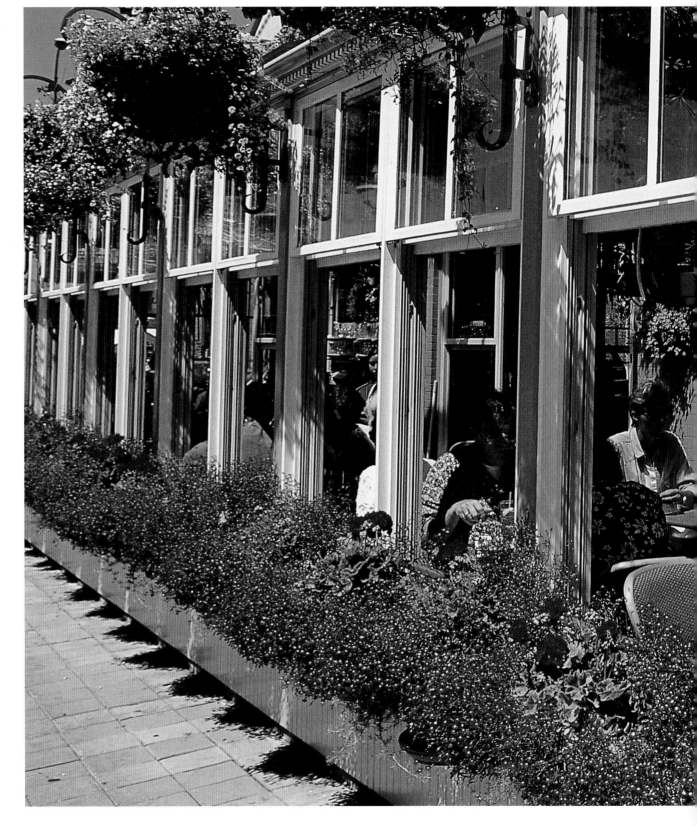

Swans Hotel was built in 1913 as a grain warehouse and later became a feed store and greenhouse. Today, the grain on the premises is used to brew some of Victoria's most famous beer, and travellers delight in the café, pub, and 29 suites in the heritage building.

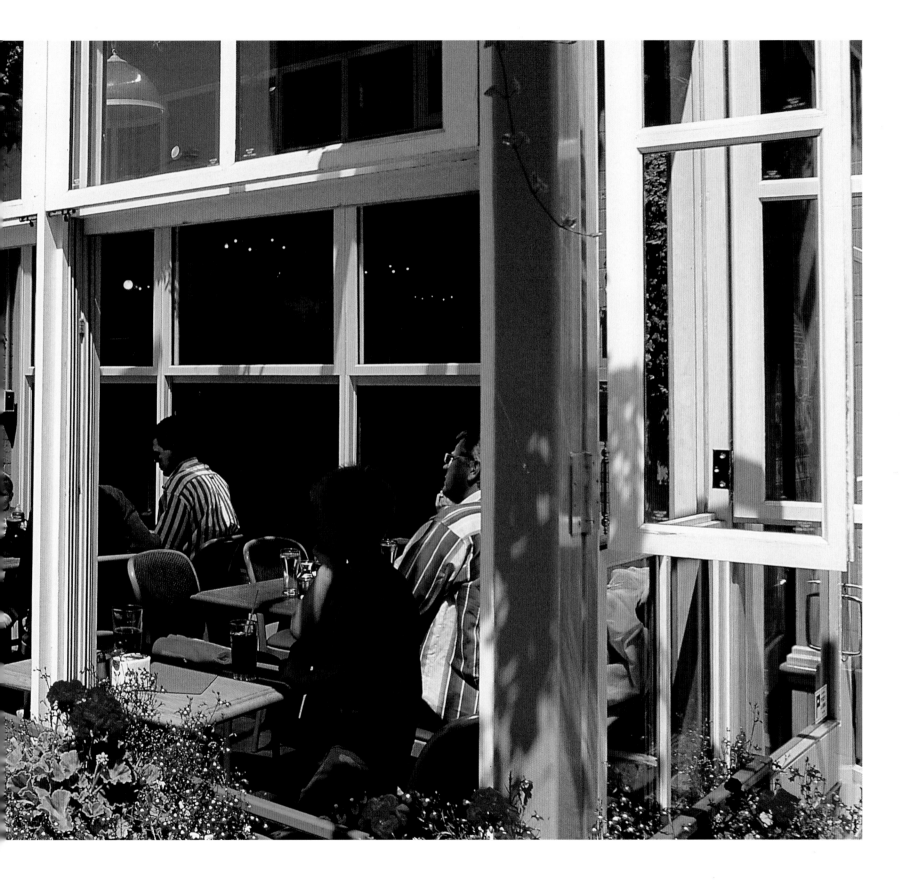

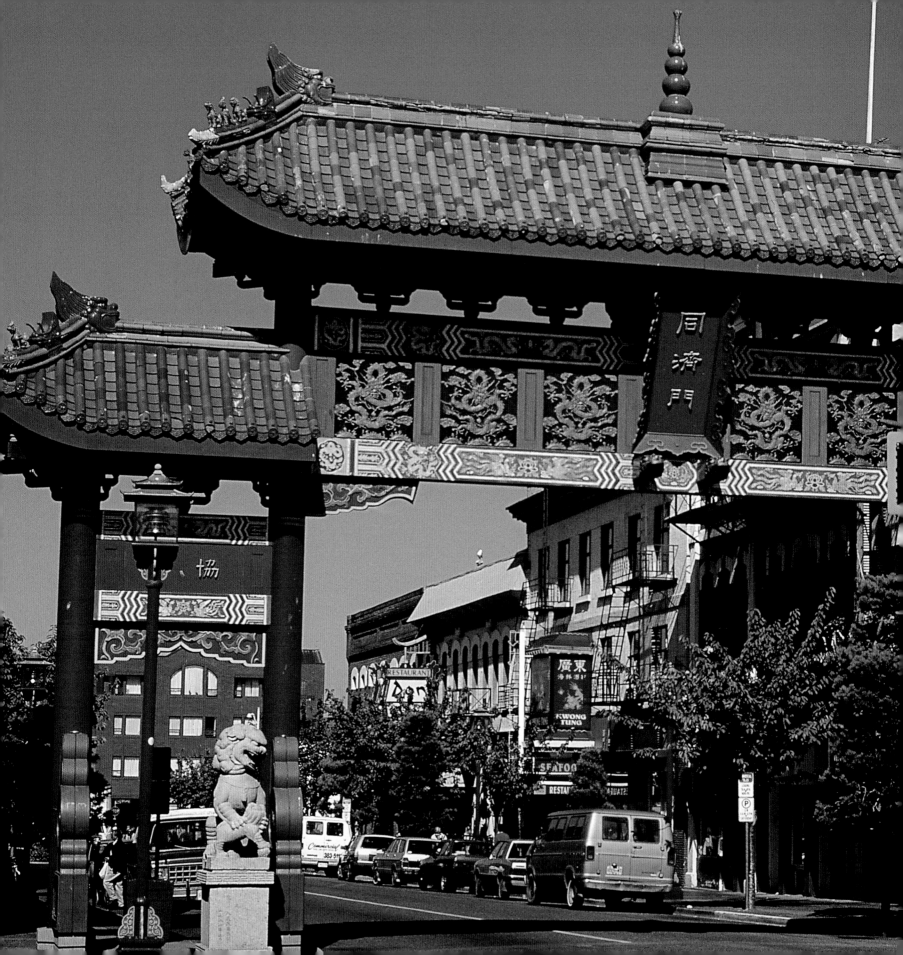

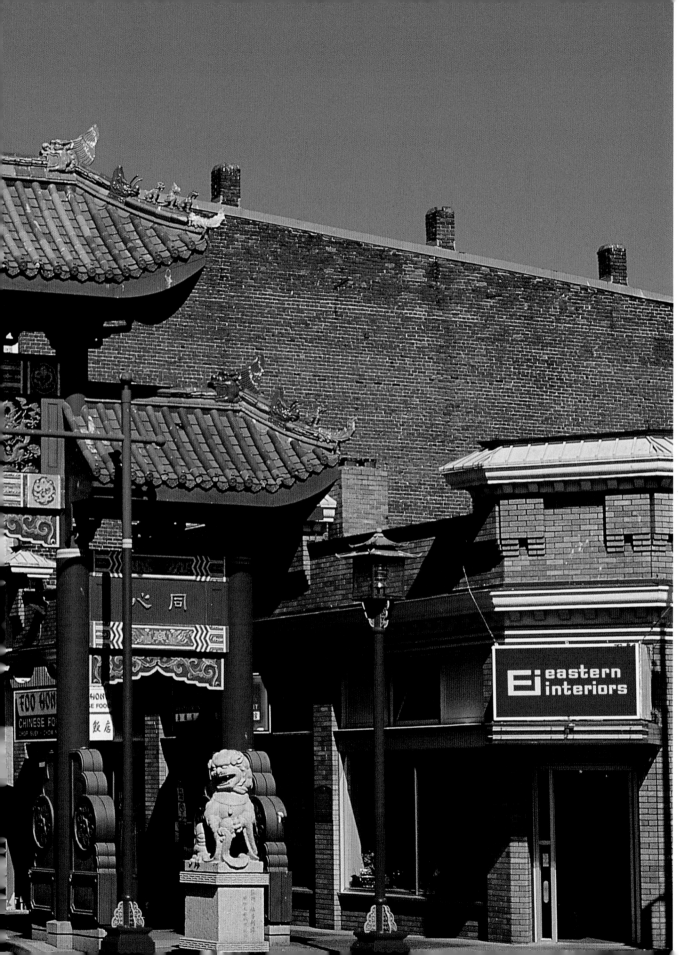

Victoria had the largest Chinese population in Canada at the turn of the century. Chinatown, just north of downtown, remains a lively neighbourhood of restaurants, produce stores, and specialty import shops.

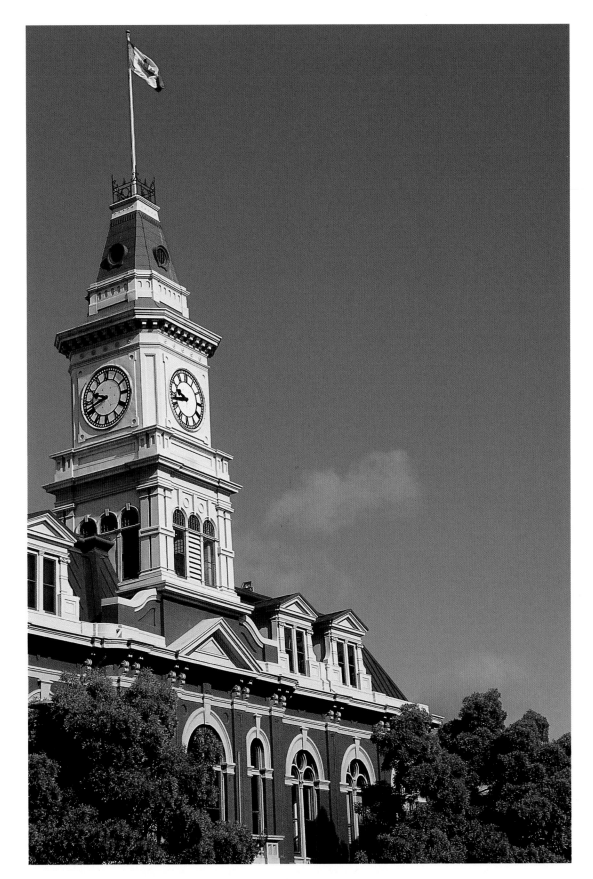

Victoria was incorporated in 1862, and became the capital of the new province of British Columbia in 1871. City Hall, designed by local resident John Teague, was completed a few years later. Victoria remained the largest city in the province for much of the nineteenth century.

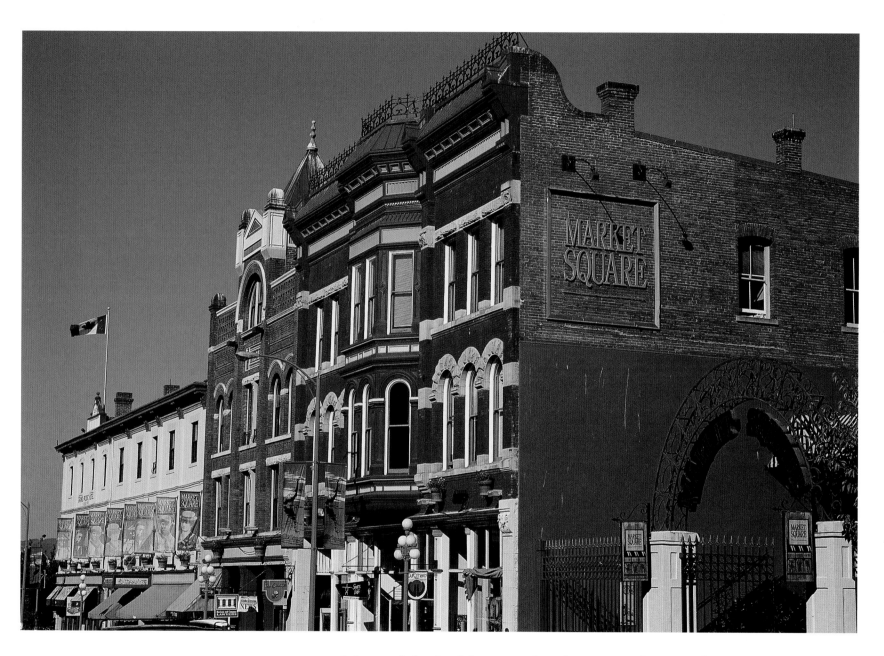

Many of the buildings in the shopping plaza Market Square were hotels and homes in the late 1800s, when Victoria's busy port brought merchants and travellers to the city.

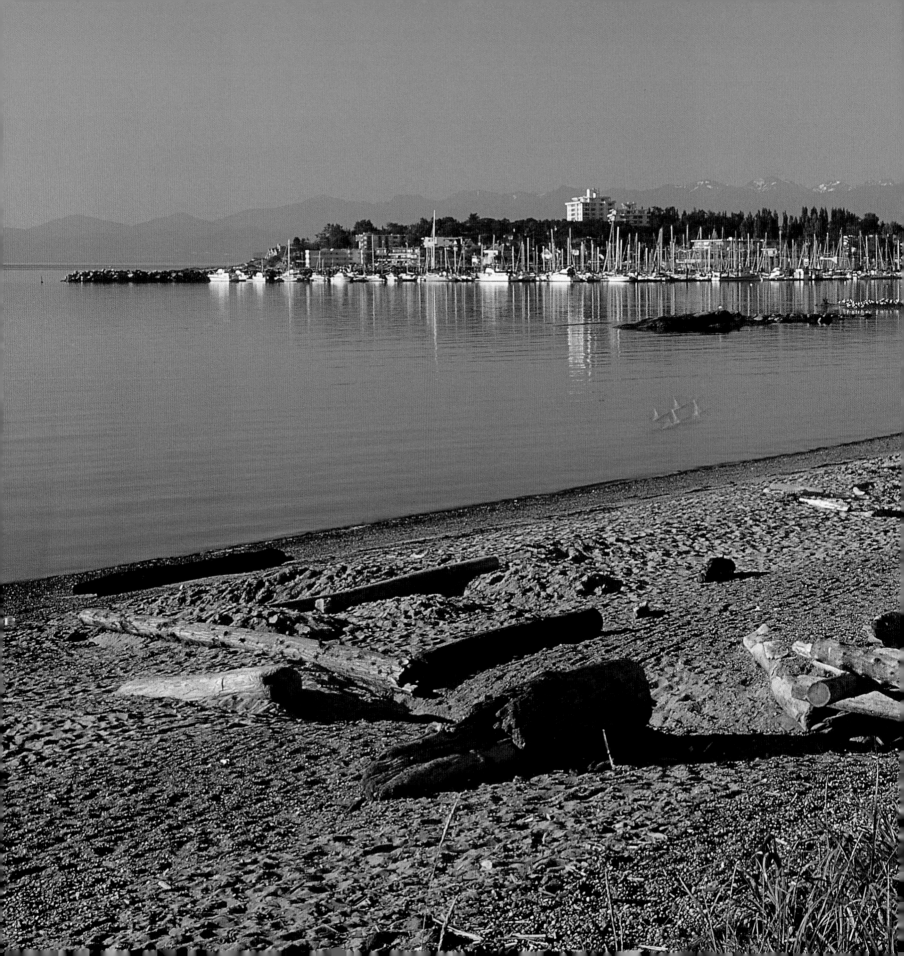

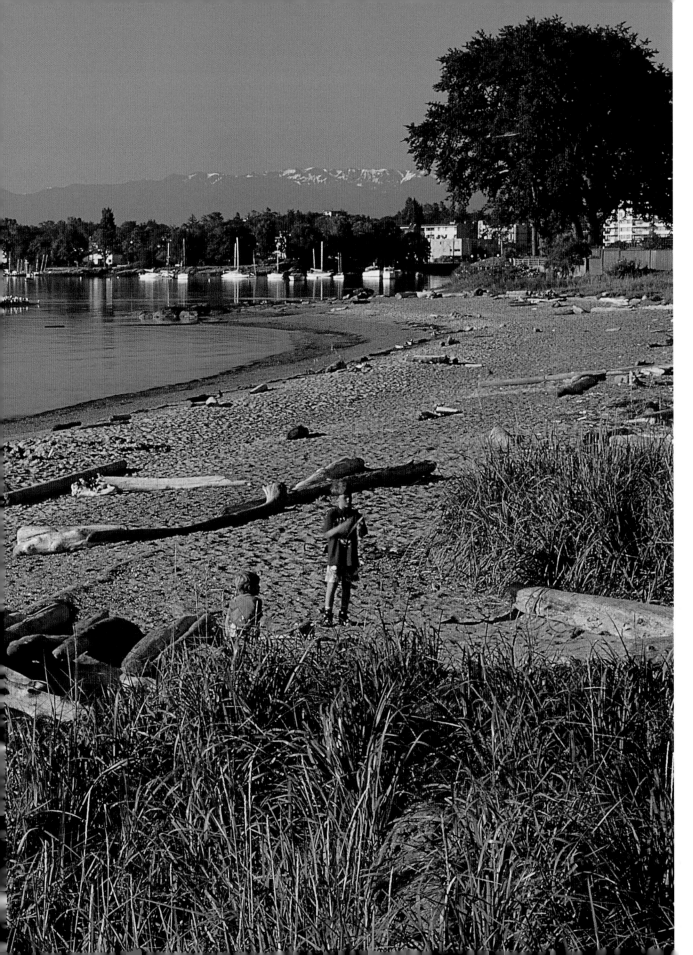

Children play on Willows Beach in Oak Bay. This quiet neighbourhood in Greater Victoria has retained its old-world charm and friendly atmosphere. Architect Francis Mawson Rattenbury, who designed the Legislative Buildings, said Oak Bay was one of the loveliest residential areas he had ever seen.

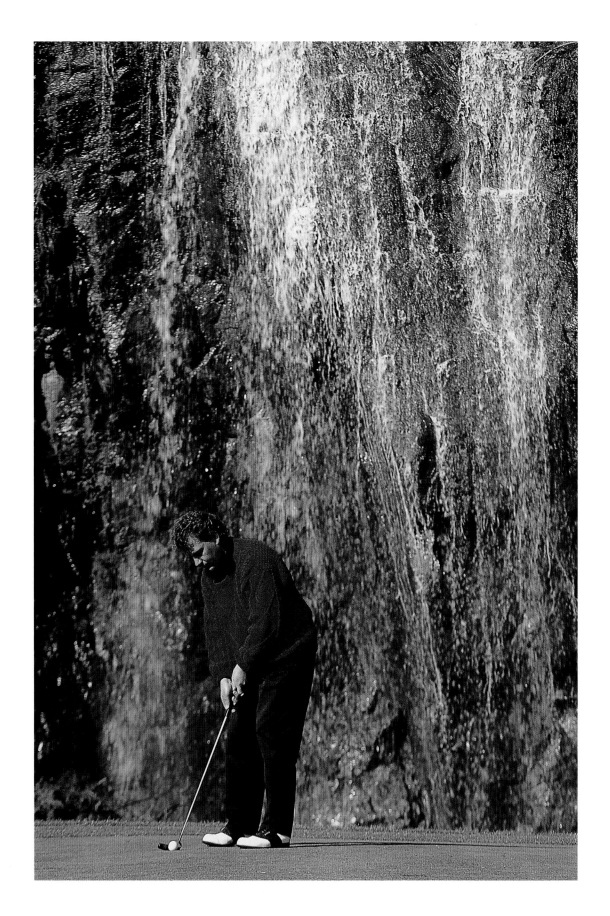

Former guests of Olympic View Golf Course, one of the most popular Victoria courses, include Tiger Woods. The 17th hole, with its amazing waterfall backdrop, is the most photographed spot on the golf course.

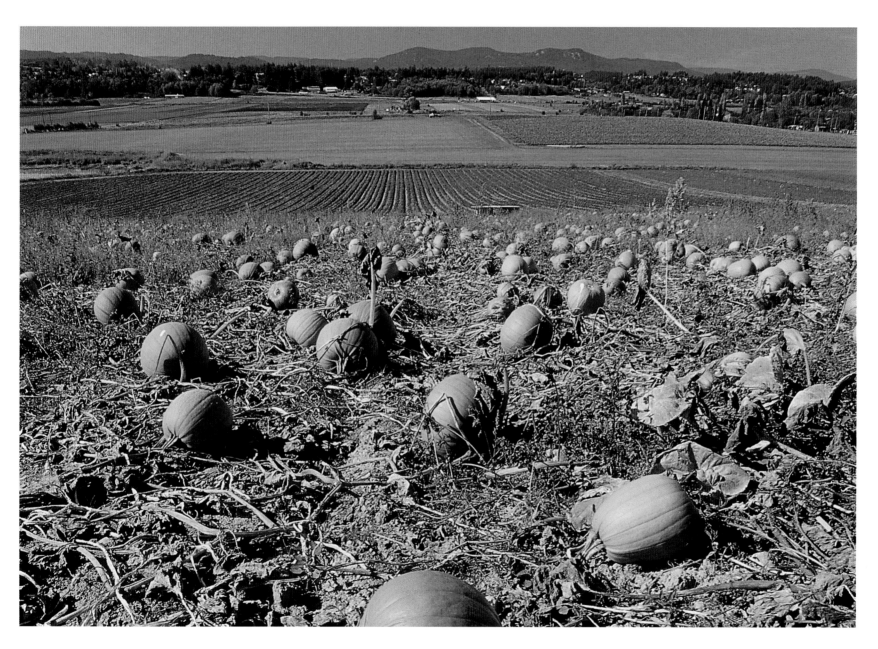

The Saanich Peninsula extends north from Victoria along Haro Strait. Much of the region is rich agricultural land, famed for daffodil crops in spring and pumpkin harvests in fall. In fact, the name *Saanich* stems from a native word meaning "fertile soil."

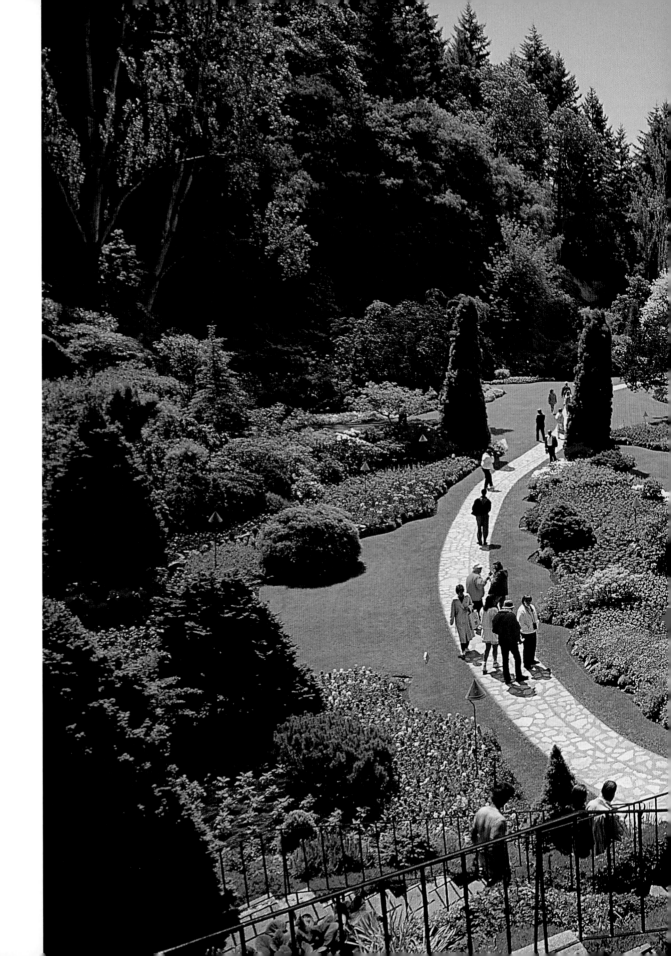

The lush plantings of the Sunken Garden at Butchart Gardens cover a former limestone quarry, created by the Butchart family cement business. Jenny Butchart embarked on a plan to transform the land in 1904. By the 1920s, the gardens drew 50,000 visitors each year. Today they attract more than a million.

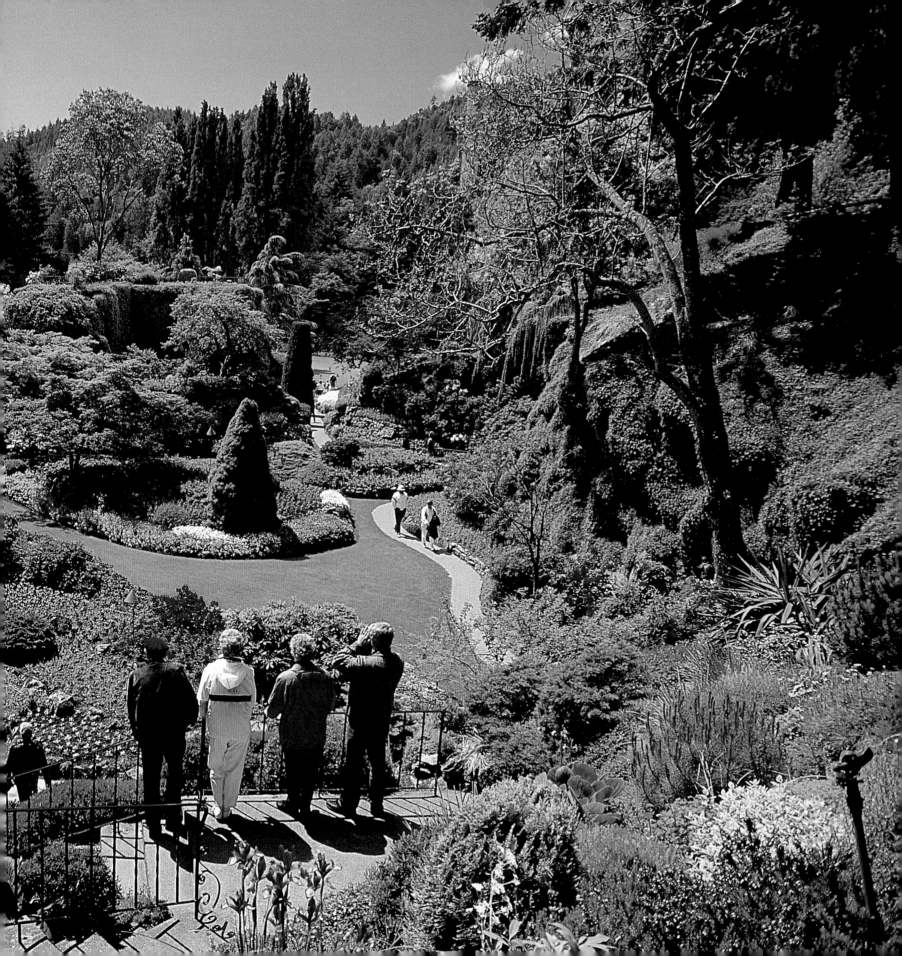

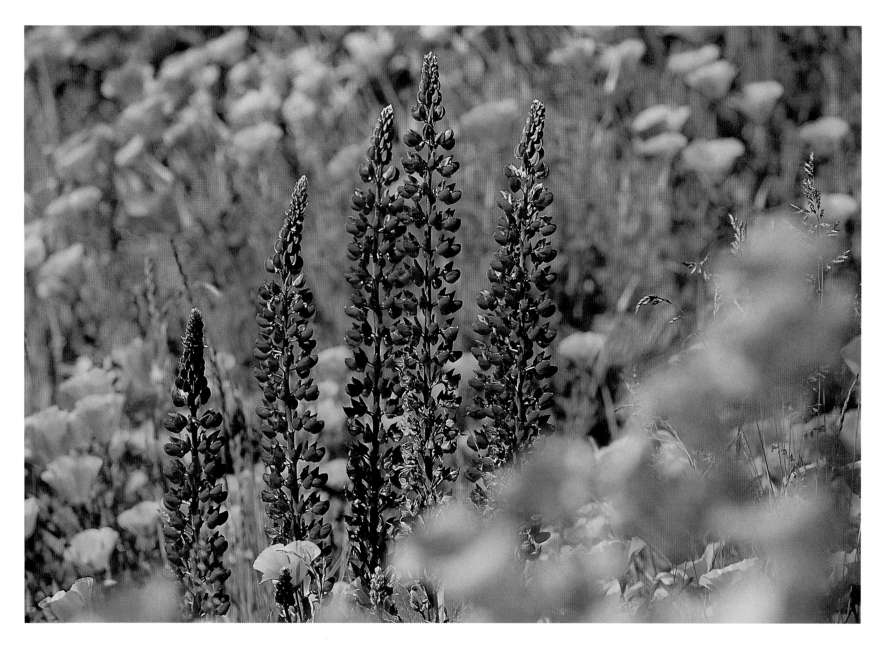

Lupines bloom in a field of California poppies, creating a splash of colour in the rolling hills of the Saanich Peninsula.

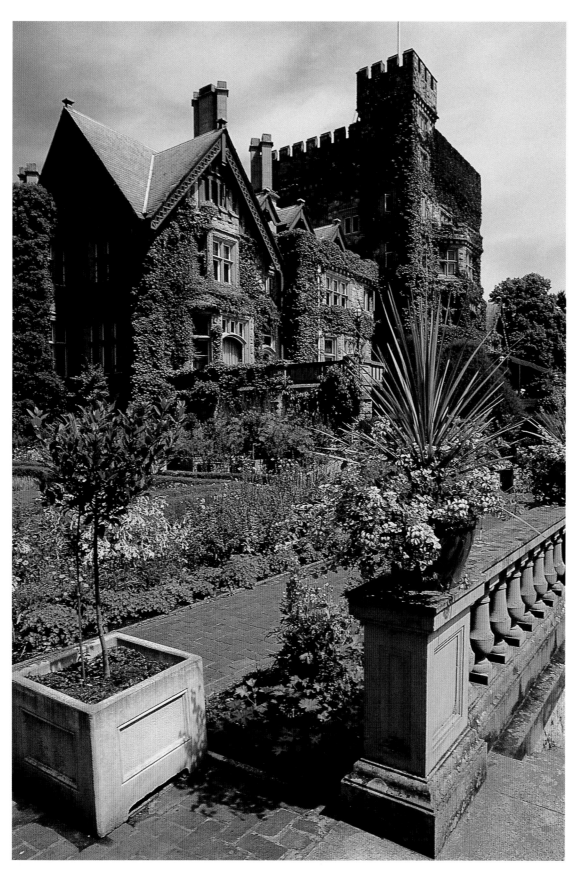

Commissioned by Lieutenant-Governor James Dunsmuir in 1908, Hatley Castle was designed by local architect Samuel Maclure as part of a country estate. The federal government purchased the sandstone mansion in 1940 and it is now the administrative centre of Royal Roads University.

35

The Songhees land was once a native settlement, but the area was sold to the B.C. government in 1910. After a period as an industrial area, the waterfront neighbourhood is now home to condominiums and a seaside walkway.

British Columbia's first permanent beacon, Fisgard Lighthouse, was built in 1860 at the entrance to Esquimalt Harbour. The lighthouse and the neighbouring artillery fort are now a national historic site.

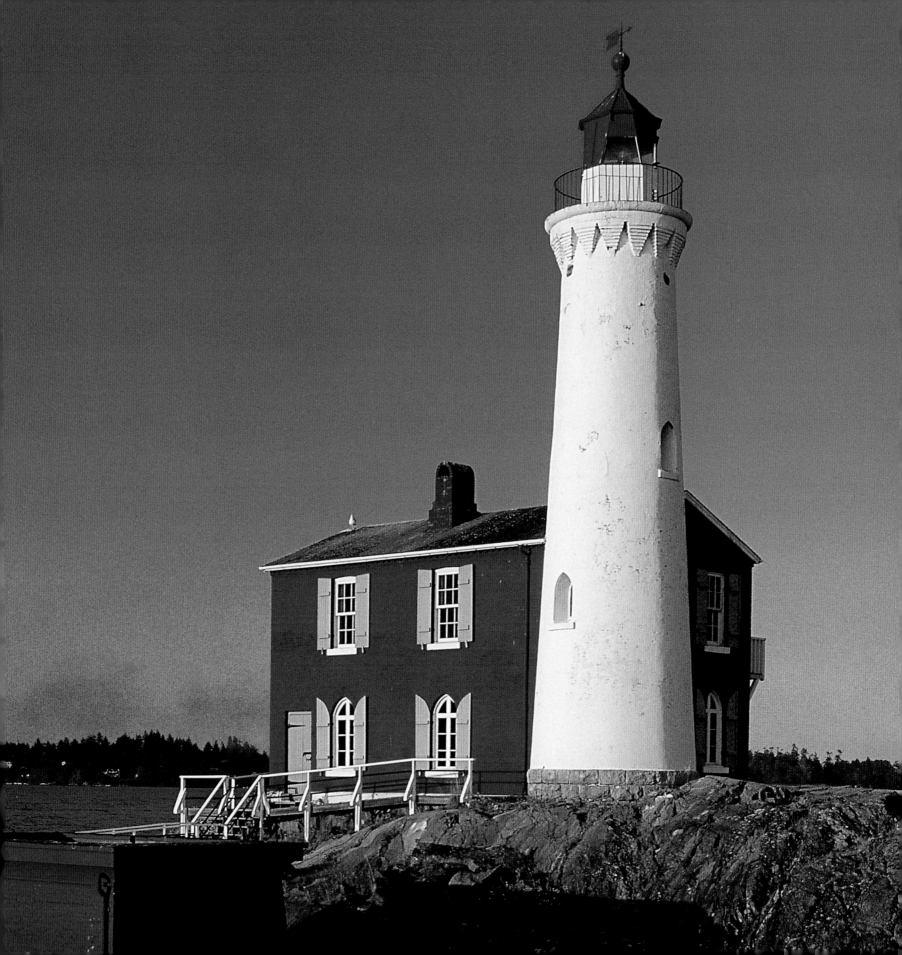

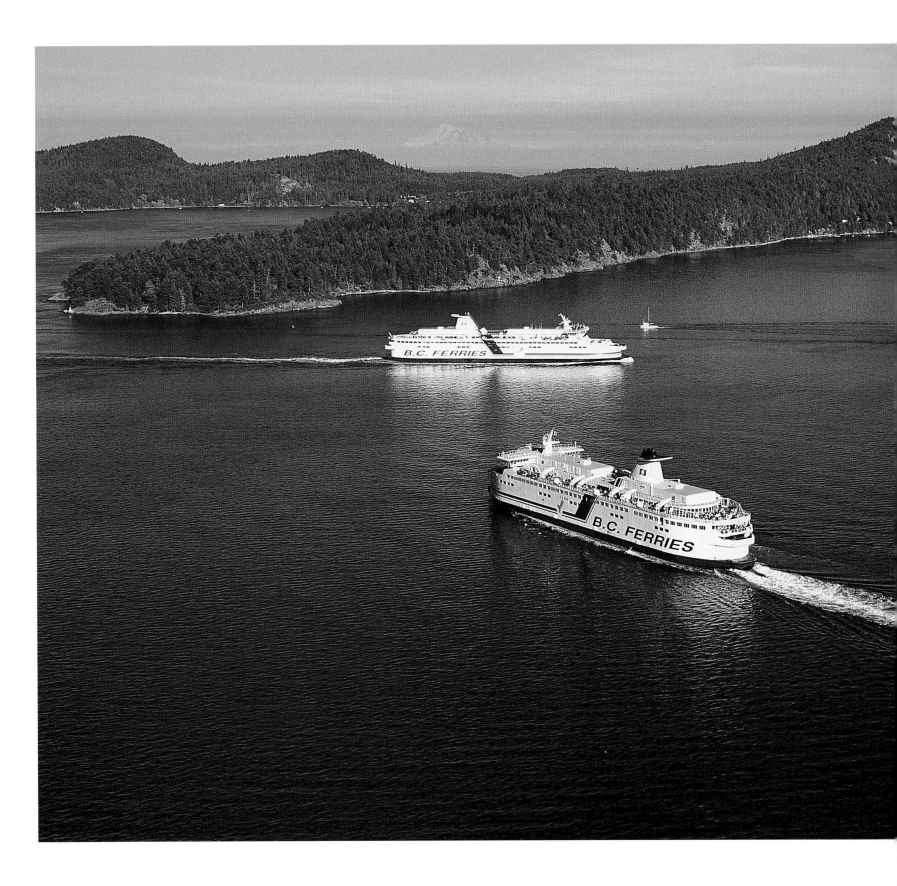

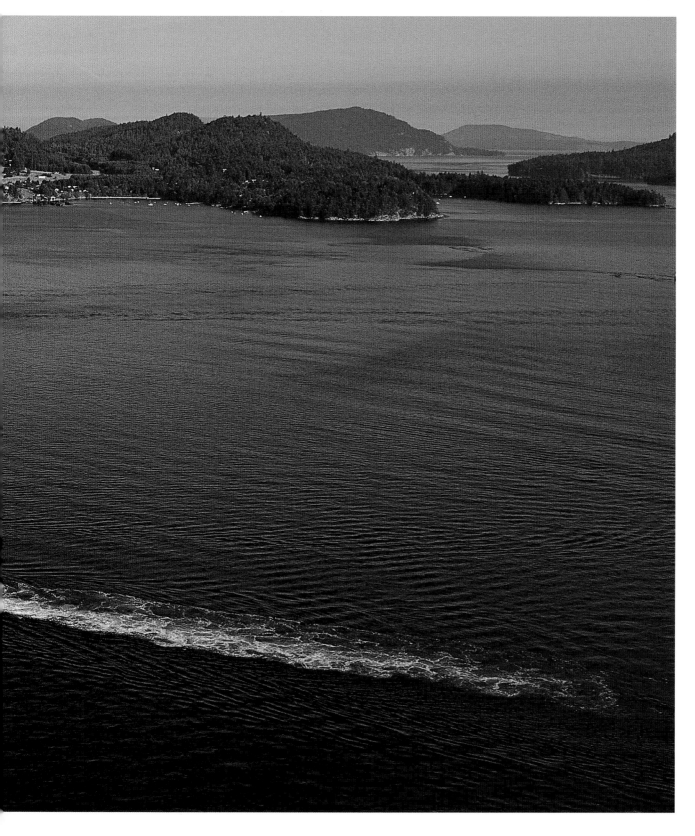

BC Ferries' fleet includes 40 vessels, from the Superferries —giant ships the length of two football fields—to ships carrying just over a hundred people. In total, the ferries serve 46 ports along the coast. Active Pass, shown here, is one of the most scenic points on the journey from Tsawwassen, on the mainland, to Swartz Bay on Vancouver Island.

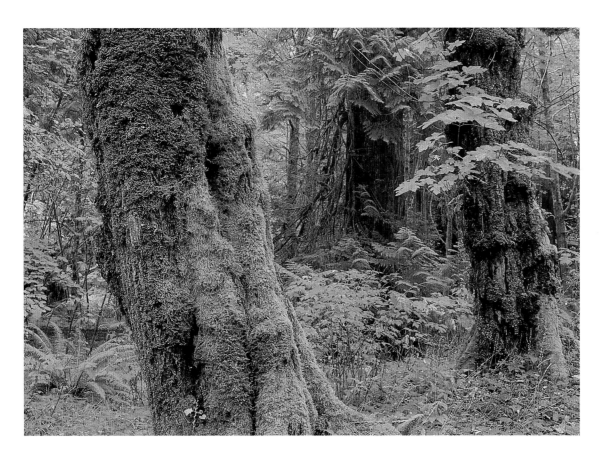

Goldstream Provincial Park, about 20 kilometres (12 miles) from down-town Victoria, features 600-year-old evergreens and Goldstream River Estuary, a favourite spot for bird-watchers.

At Sooke Harbour House, 28 guest rooms provide luxury accommodation, while the inn's chefs create gourmet meals from herbs, vegetables, and edible flowers grown in the famous kitchen gardens.

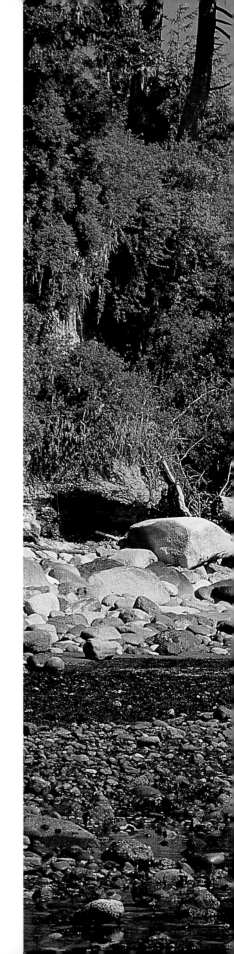

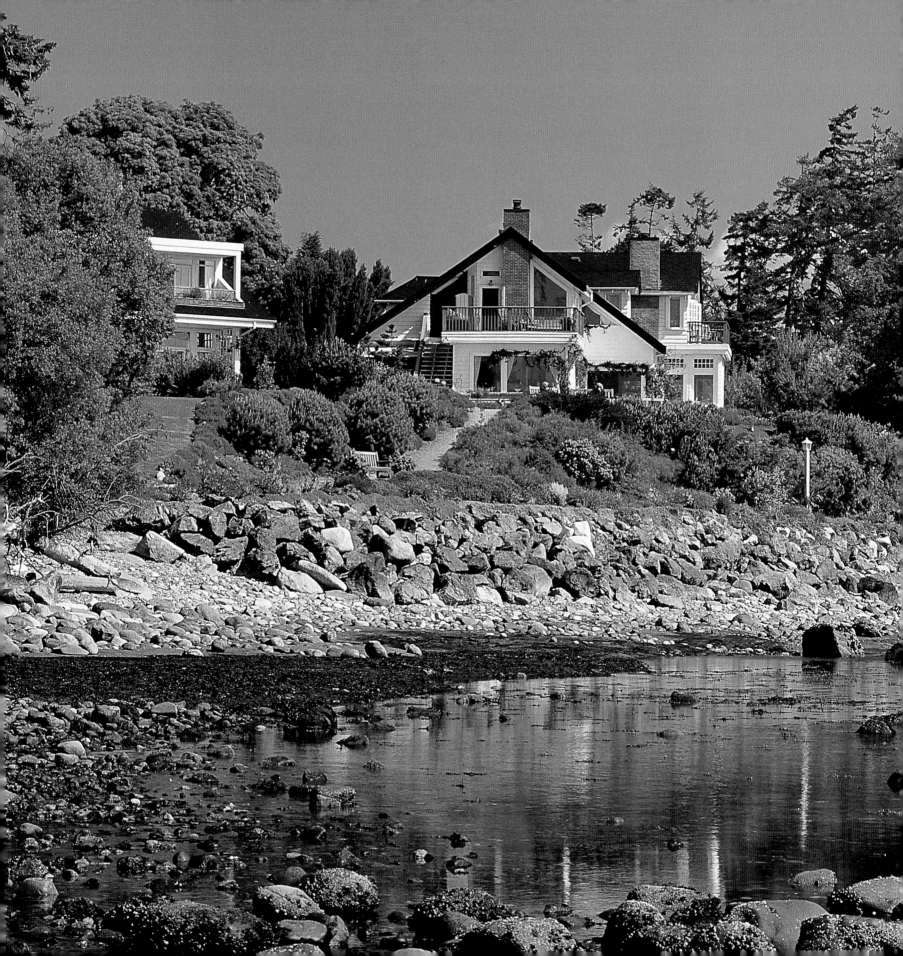

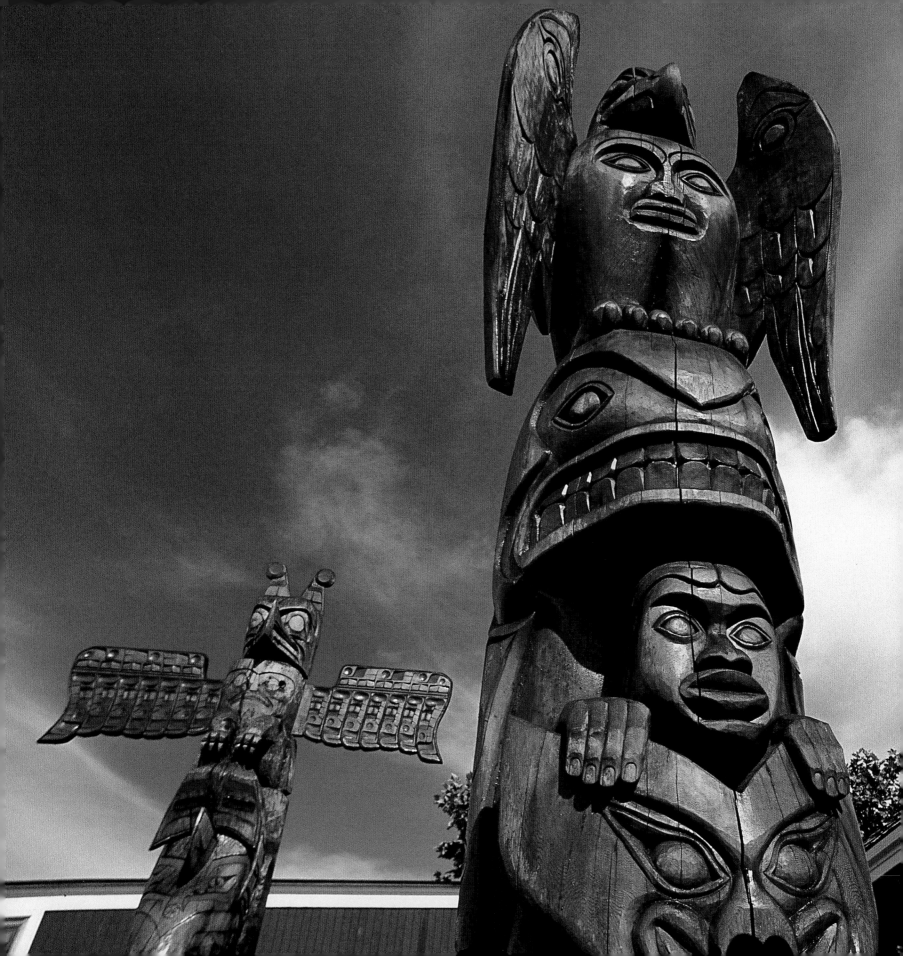

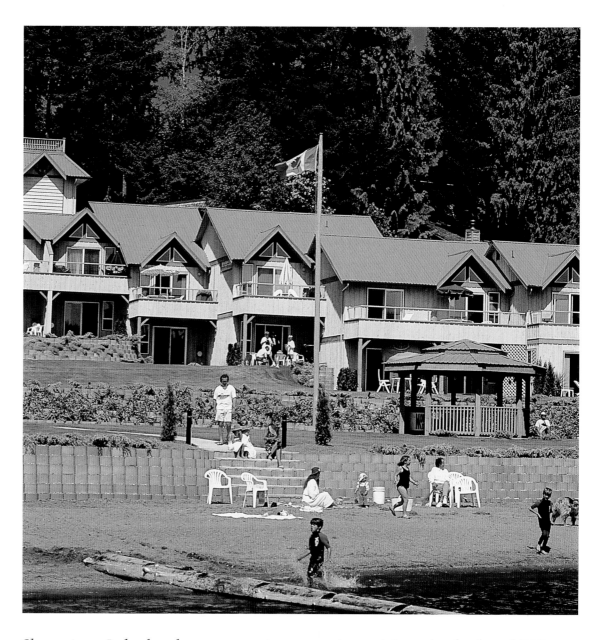

Shawnigan Lake has been a vacation spot since visitors in the late 1800s rode the Esquimalt & Nanaimo Railway to lodges along the lake. Nearby wineries and golf courses continue to draw vacationers.

Duncan has earned the title City of Totems for the elaborately carved works placed throughout the community. A collaboration between native carvers and the city, the Totem Pole Project celebrates the continuing importance of the art form.

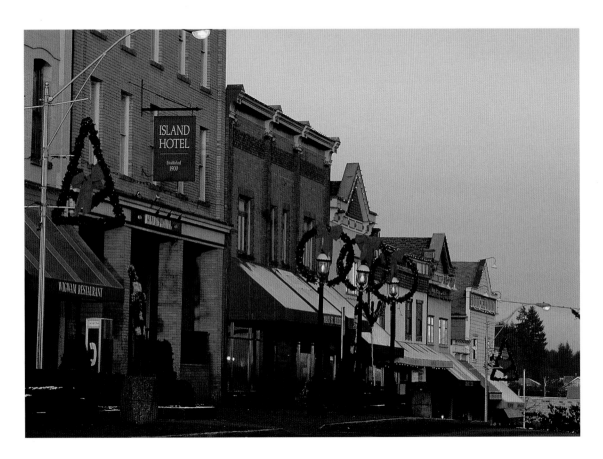

Originally home to coal miners at the turn of the century, Ladysmith has since become a logging base and, most recently, a tourism destination.

When the local mill closed in Chemainus in 1983, residents fought to save the community. They created more than 30 murals depicting the area's rich history, and now more than 300,000 visitors flock to Chemainus each year.

Ice Cream Par

yogurt

BELGIAN
WAFFLES

yogurt

Billy's
Delight
Famous Waffle
Cones

OVER
1.0
million
served

BillyThomas

SANDY CLAR

13

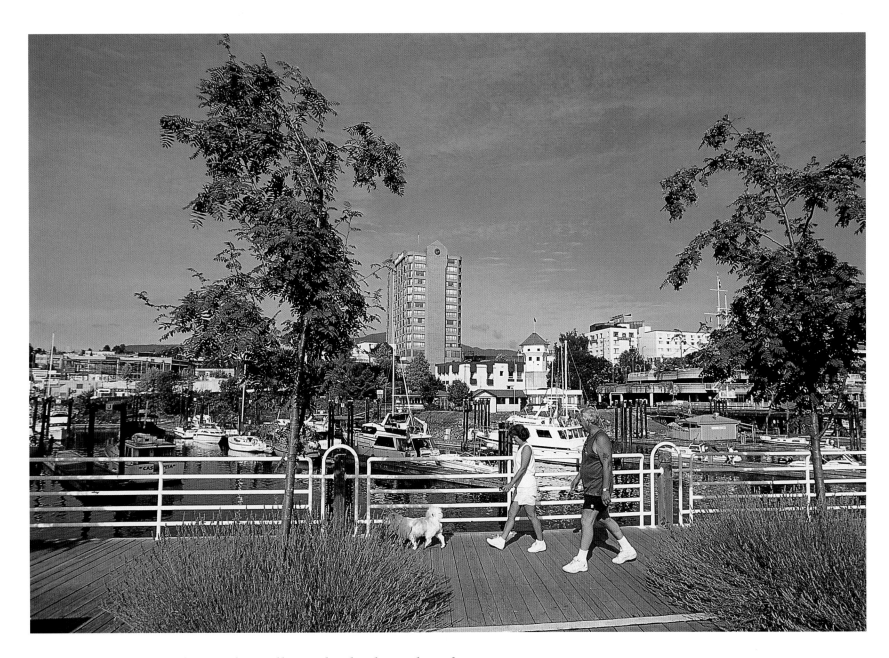

The picturesque Harbourside Walkway leads along the edge
of Nanaimo's port, where more than a million tonnes of cargo
are processed each year. Sightseers can wander for more than
4 kilometres (2.5 miles) along the waterfront.

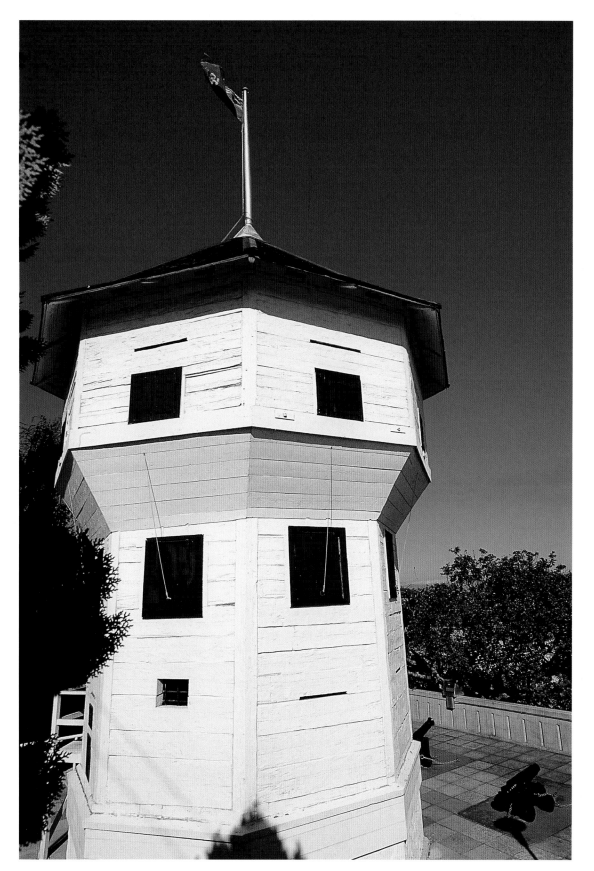

Built in 1853 as part of the defenses for a Hudson's Bay Company settlement, the Bastion in Nanaimo now serves as a seasonal tourist information centre. It is the only remaining Hudson's Bay Company bastion in North America.

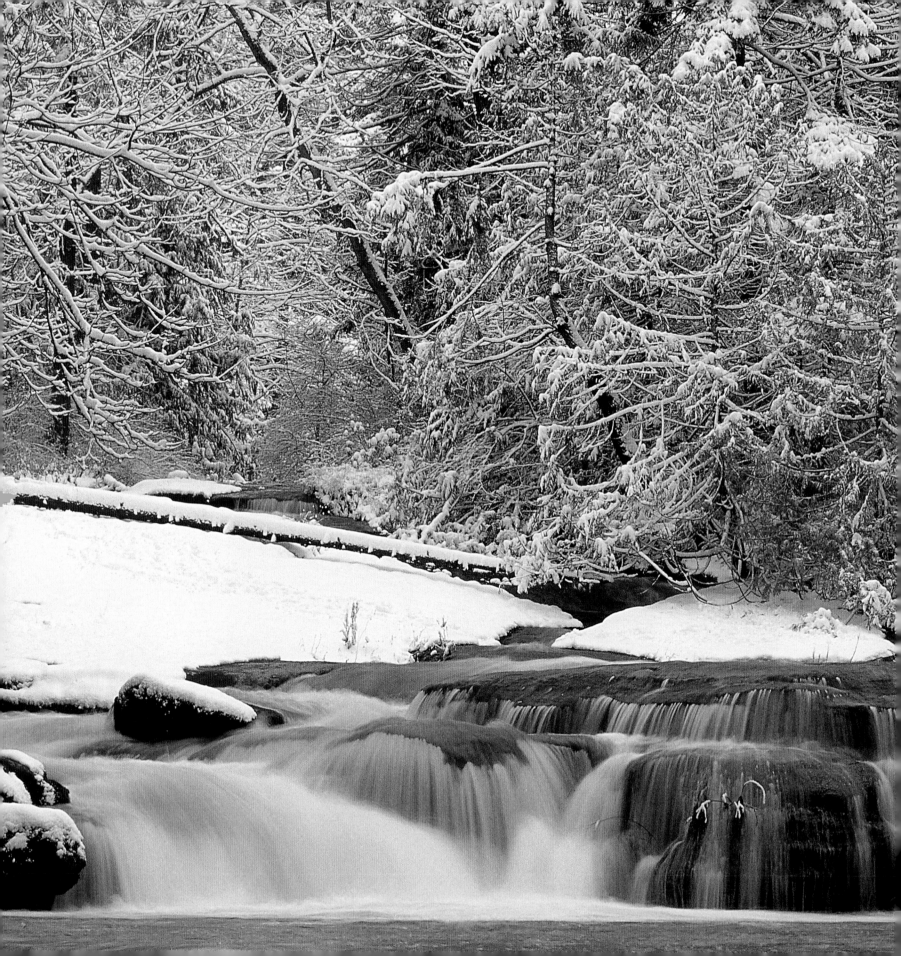

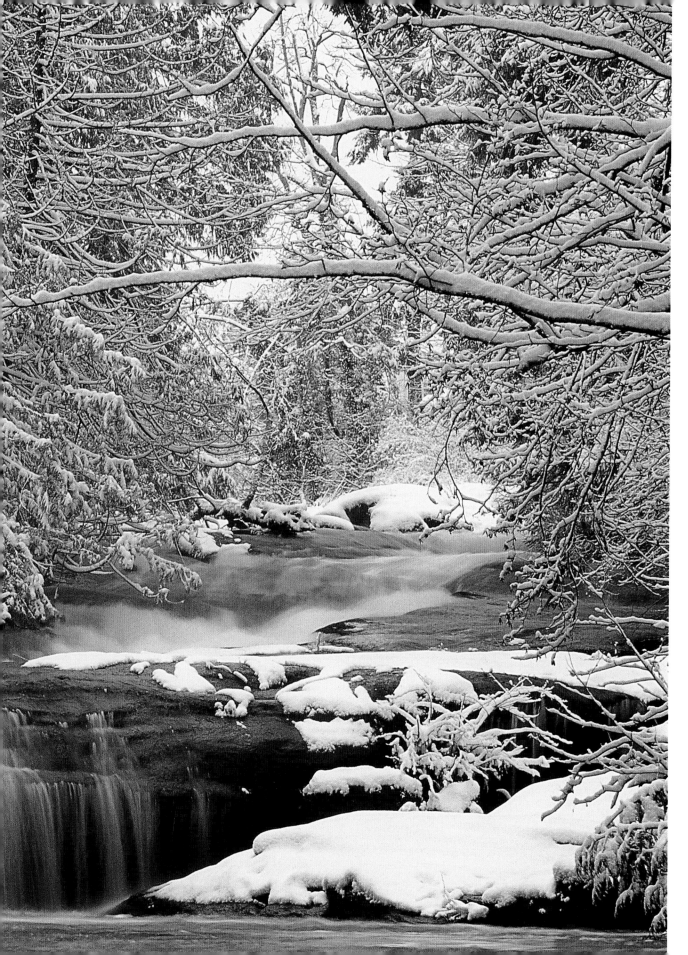

While a white Christmas is much more likely in Nanaimo than it is in Victoria, the city's climate remains relatively mild compared to the rest of the province.

49

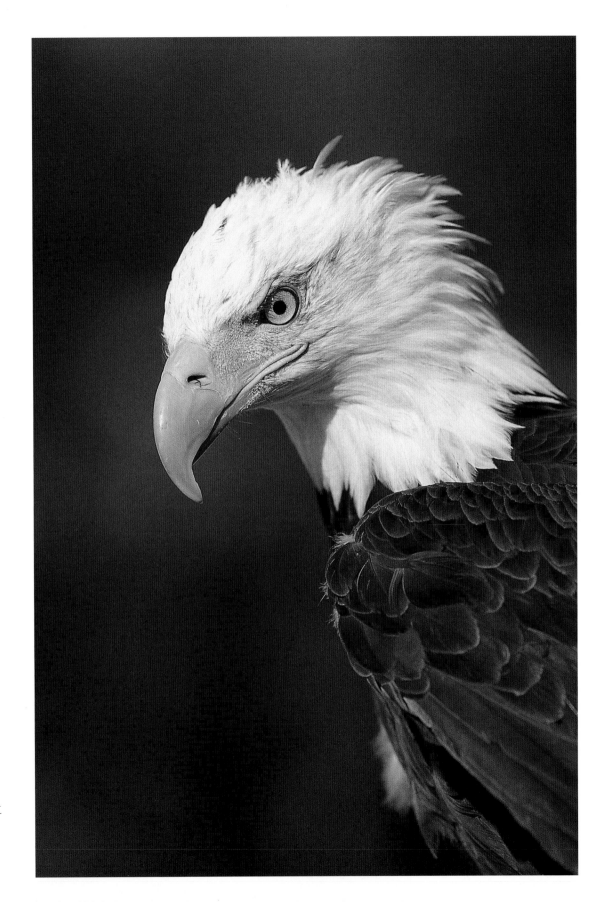

Bald eagles are often seen circling high above the waterways of Vancouver Island. The best time to catch an up-close glimpse of the raptor is in the fall, when eagles gather to feast on spawning salmon.

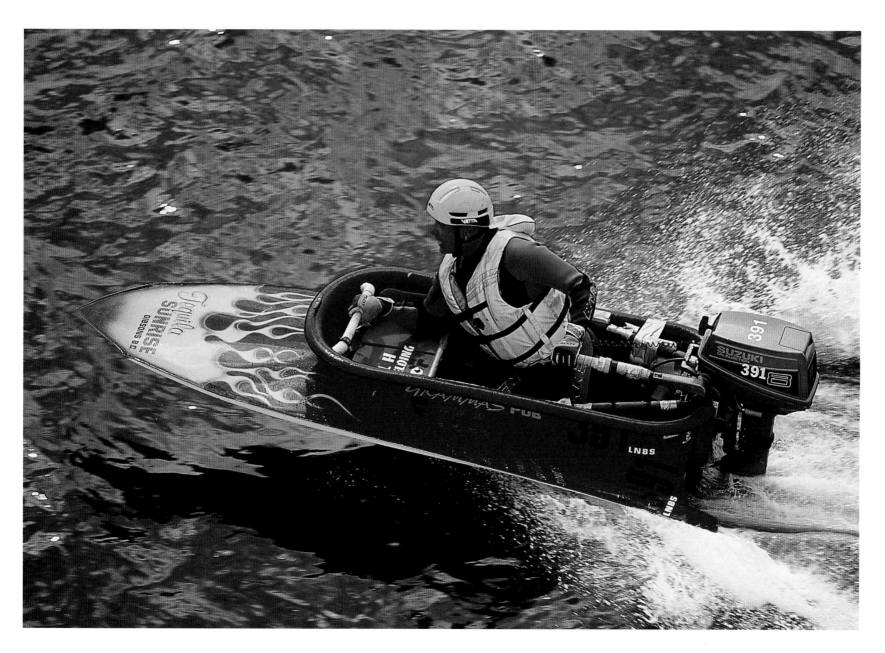

A competitor in Nanaimo's International World Championship Bathtub Race speeds through the Strait of Georgia. Participants in this annual event must fashion their vessels from old-fashioned bathtubs.

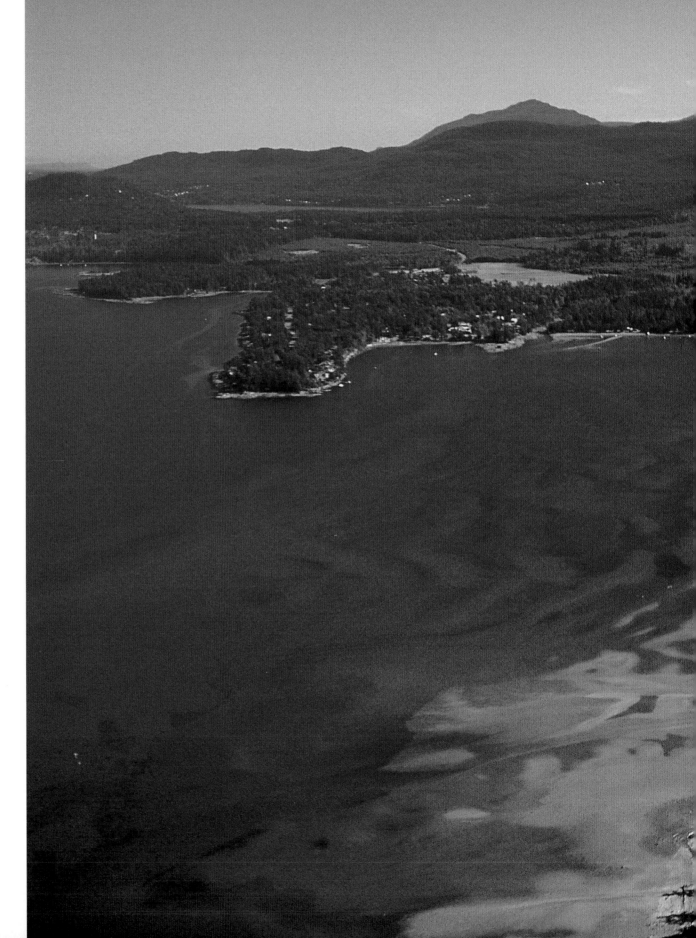

The beauty of the beaches surrounding Parksville, an annual average of 2,047 hours of sunshine, and the warmest ocean temperatures in the province combine to make this a favourite summer retreat for Vancouver Island families.

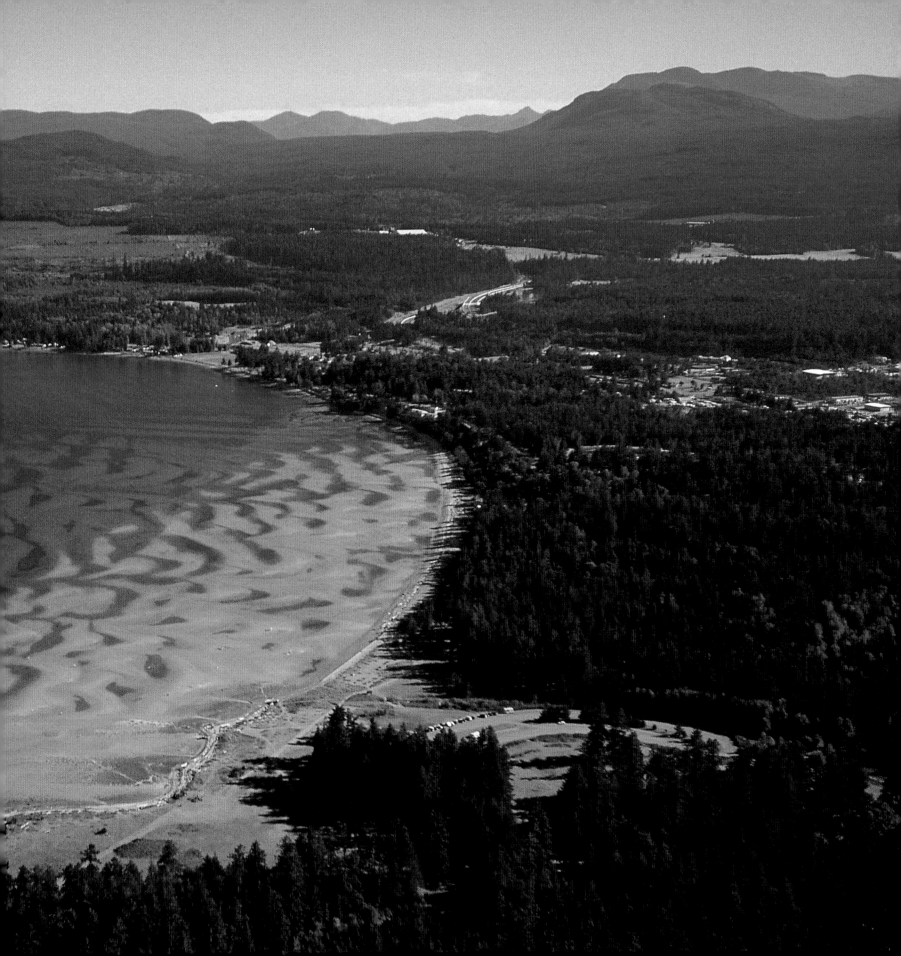

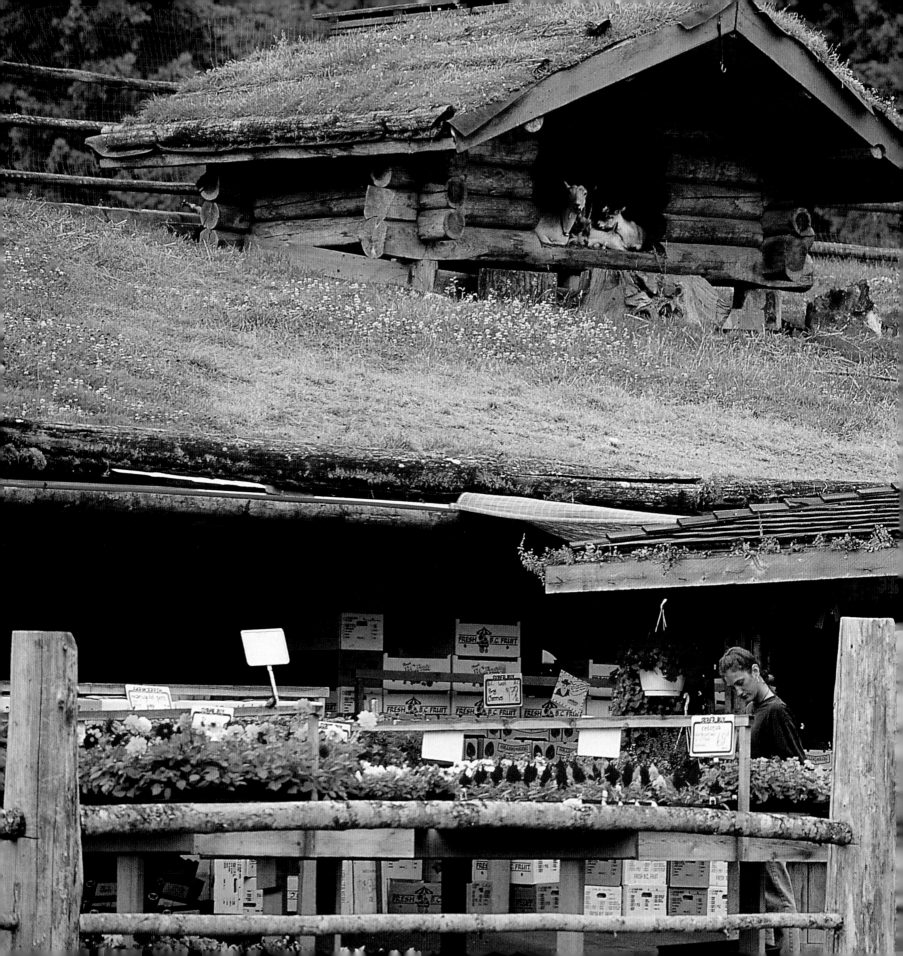

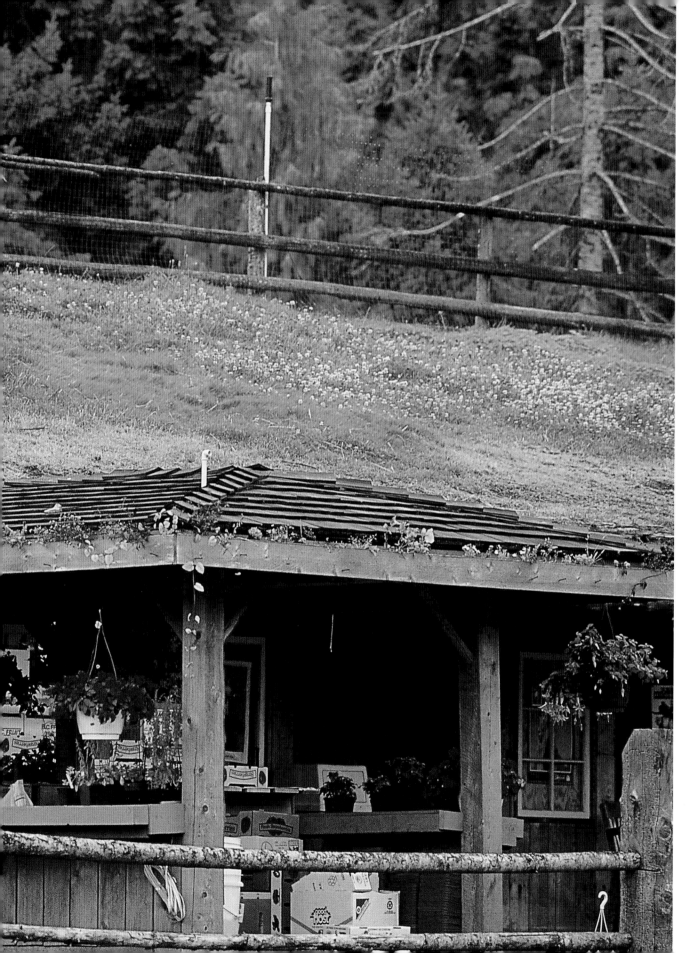

One of the favourite sights at Coombs Country Market is on the roof, where goats nibble the grass. Inside the market, fresh produce, specialty cheeses, and locally made breads tempt customers.

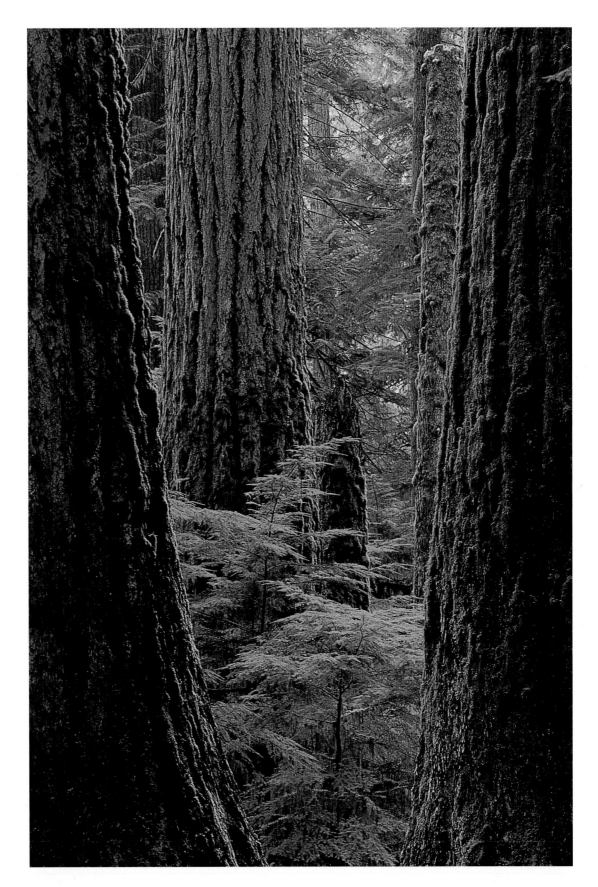

More than 800 years old, the Douglas fir trees in MacMillan Provincial Park's Cathedral Grove tower more than 60 metres (200 feet) above visitors. This land was a gift to the province from H.R. MacMillan Export Company. The company's president, Harvey Reginald MacMillan, was B.C.'s chief forester in the early 1900s.

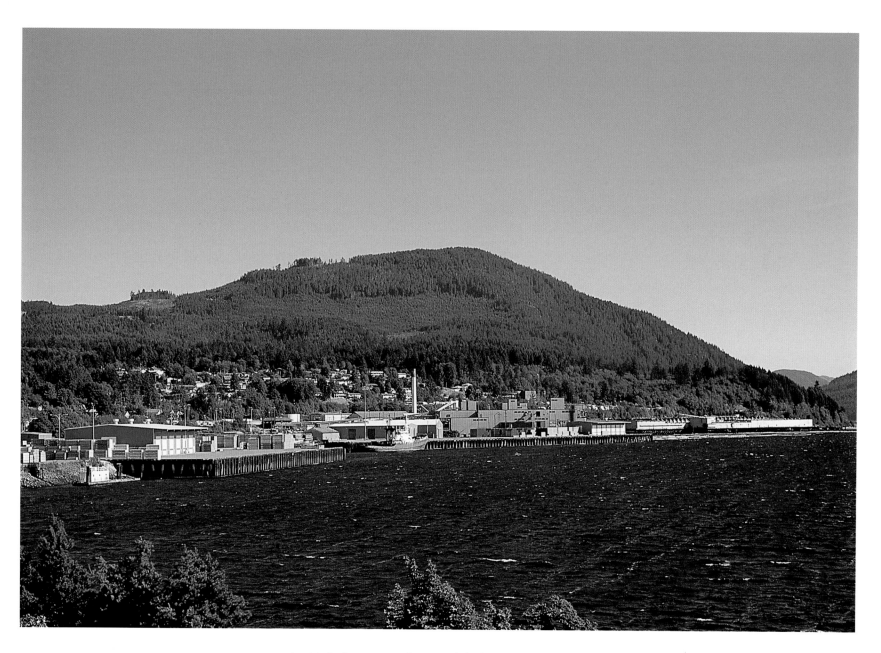

A 40-kilometre (25-mile) fiord extends from the west coast of Vancouver Island to the city of Port Alberni. Historically a logging and mill community, Port Alberni has more recently become a gateway for tourism in Pacific Rim National Park, Clayoquot Sound, and other popular island destinations.

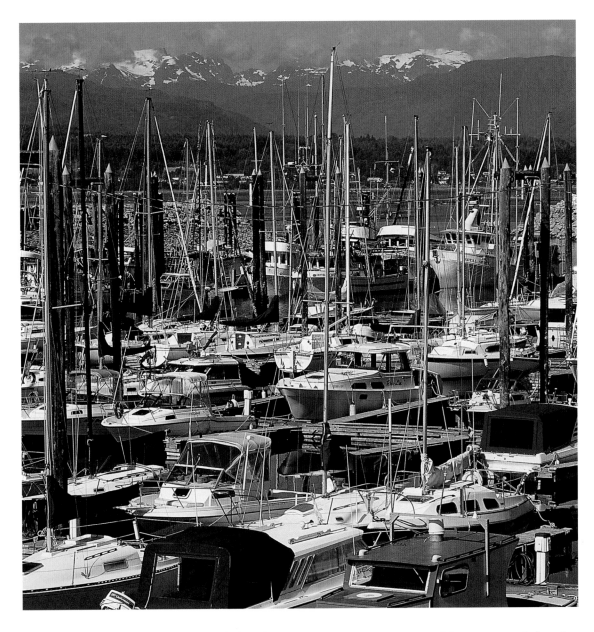

The Comox Valley is one of the fastest-growing areas on Vancouver Island. Although the fishing industry is in decline, about 300 commercial vessels still operate out of the local harbours.

Vancouver Island's largest ski resort, Mount Washington offers over 50 alpine runs, eight lifts to sweep 10,000 riders an hour up the slopes, and 40 kilometres (25 miles) of cross-country ski trails.

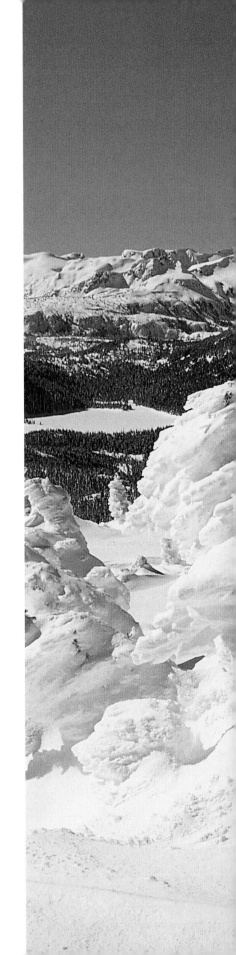

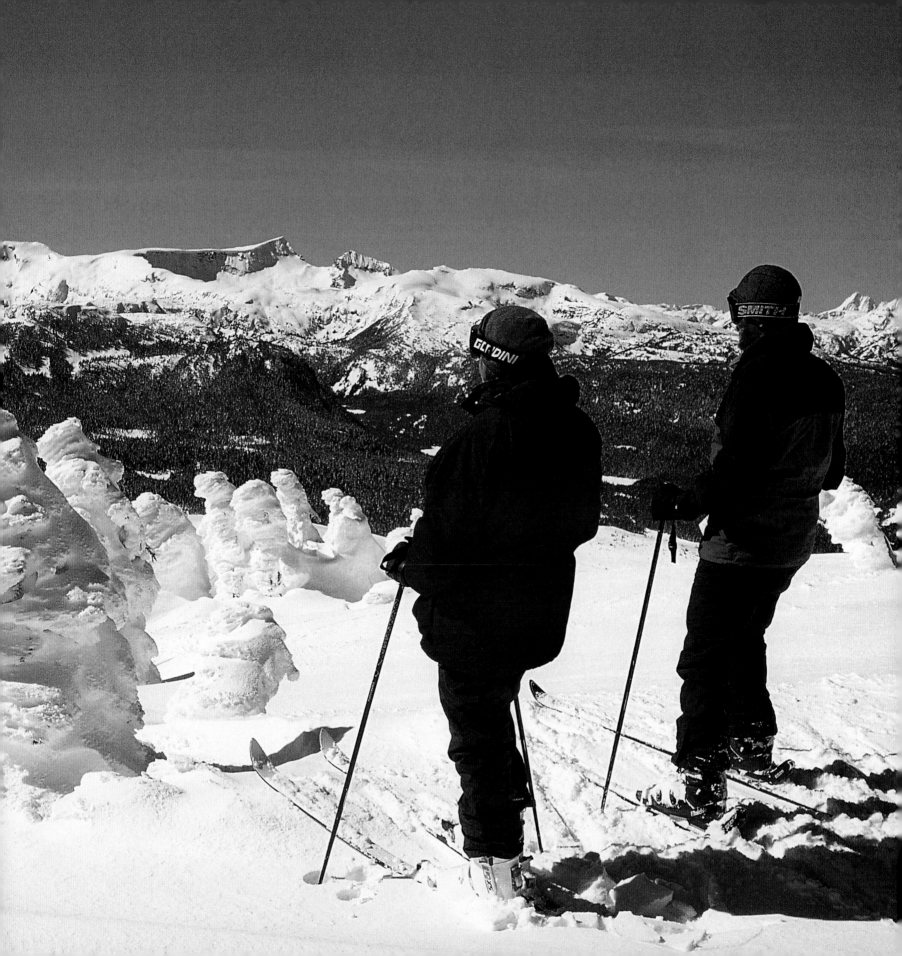

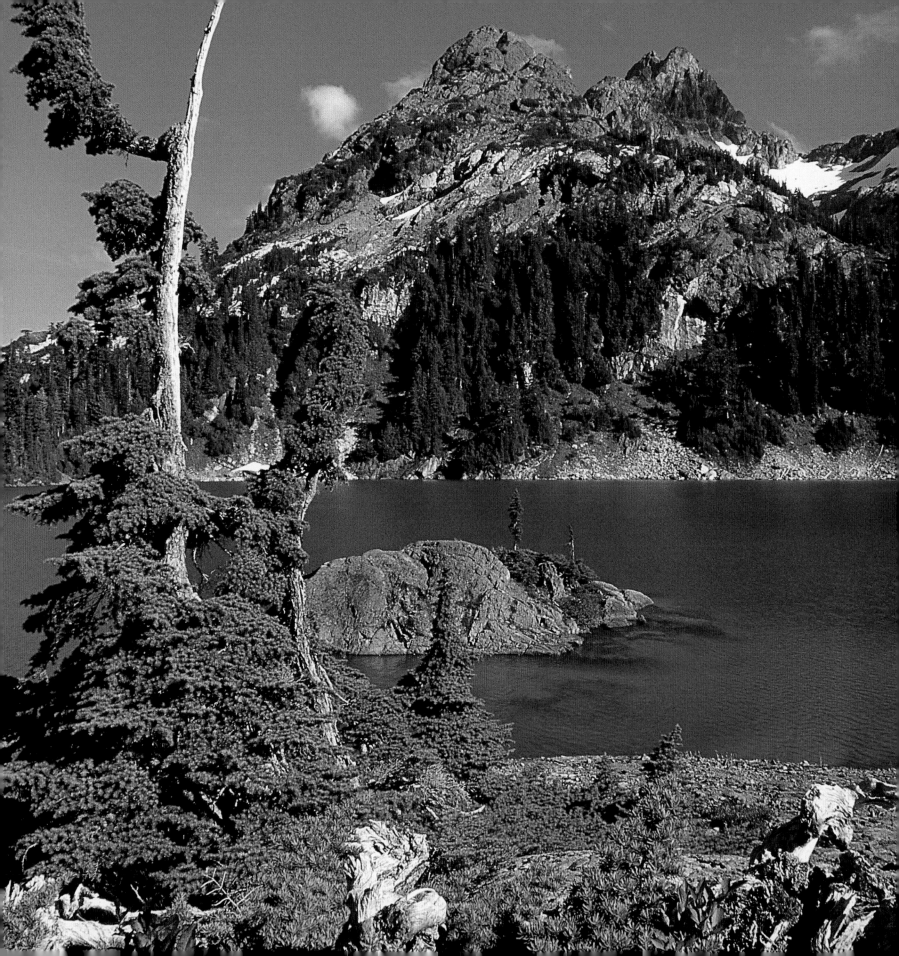

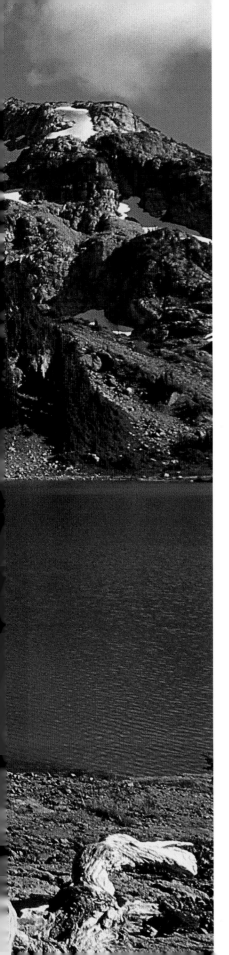

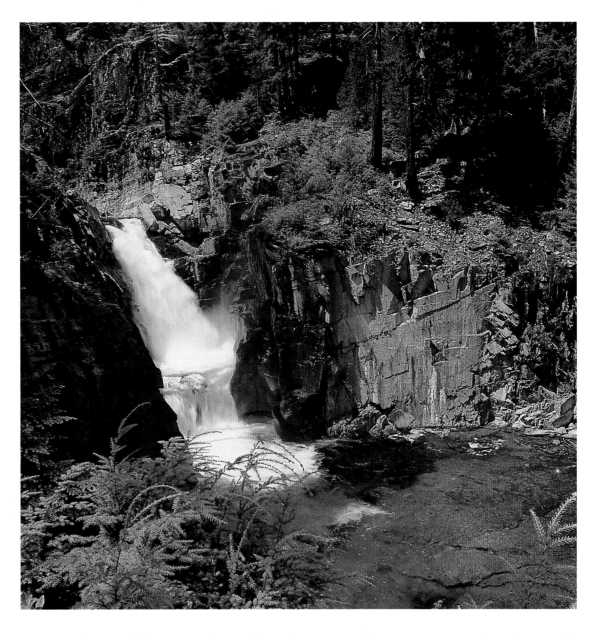

Myra Falls tumbles towards Buttle Lake in Strathcona Provincial Park. Much of the park remains undeveloped, but Buttle Lake, surrounded by towering alpine peaks, is an area popular with both picnickers and backpackers.

Established in 1911, Strathcona Provincial Park encompasses more than 250,000 hectares (618,000 acres) of mountains, glaciers, wildflower meadows, and lush valleys.

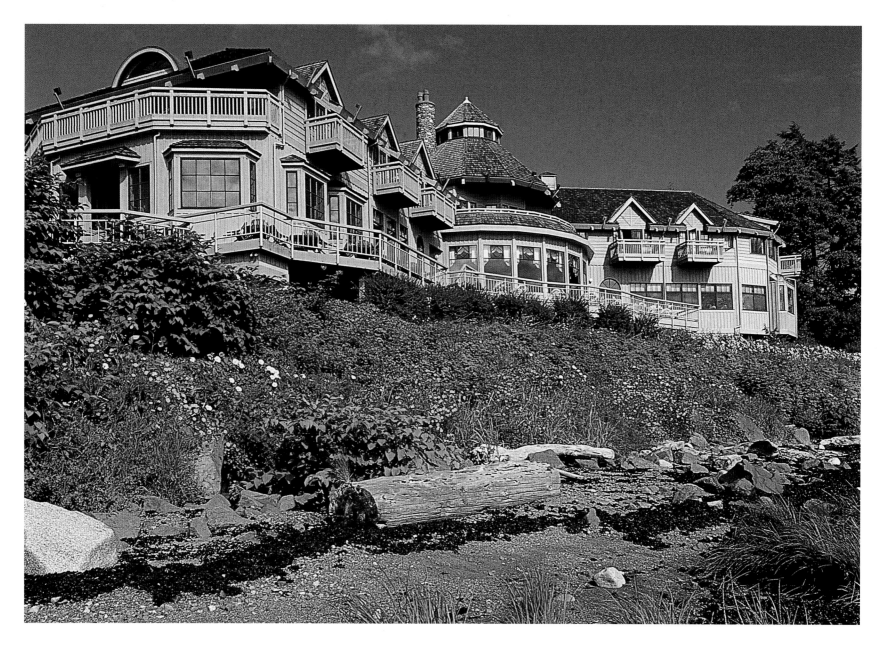

A holiday and fishing resort known to salmon fishers across the continent, Painter's Lodge Resort in Campbell River provides charter fishing, conference facilities, and magnificent views of Discovery Passage.

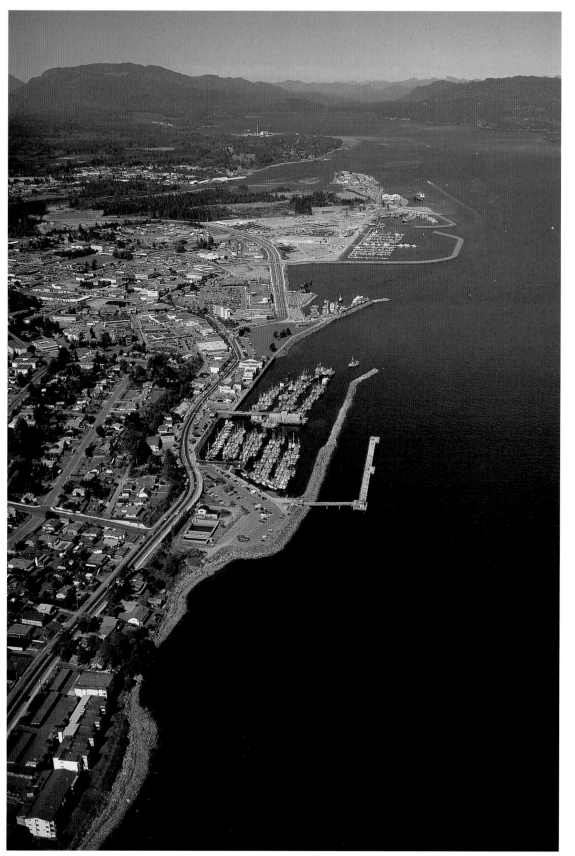

Fishing enthusiasts descend on Campbell River, self-proclaimed Salmon Capital of the World, to try their luck catching chinook, coho, sockeye, steelhead, and trout. One of the most famous former residents is Roderick Haig-Brown, an angler and conservationist who lived and wrote in Campbell River in the mid-1900s.

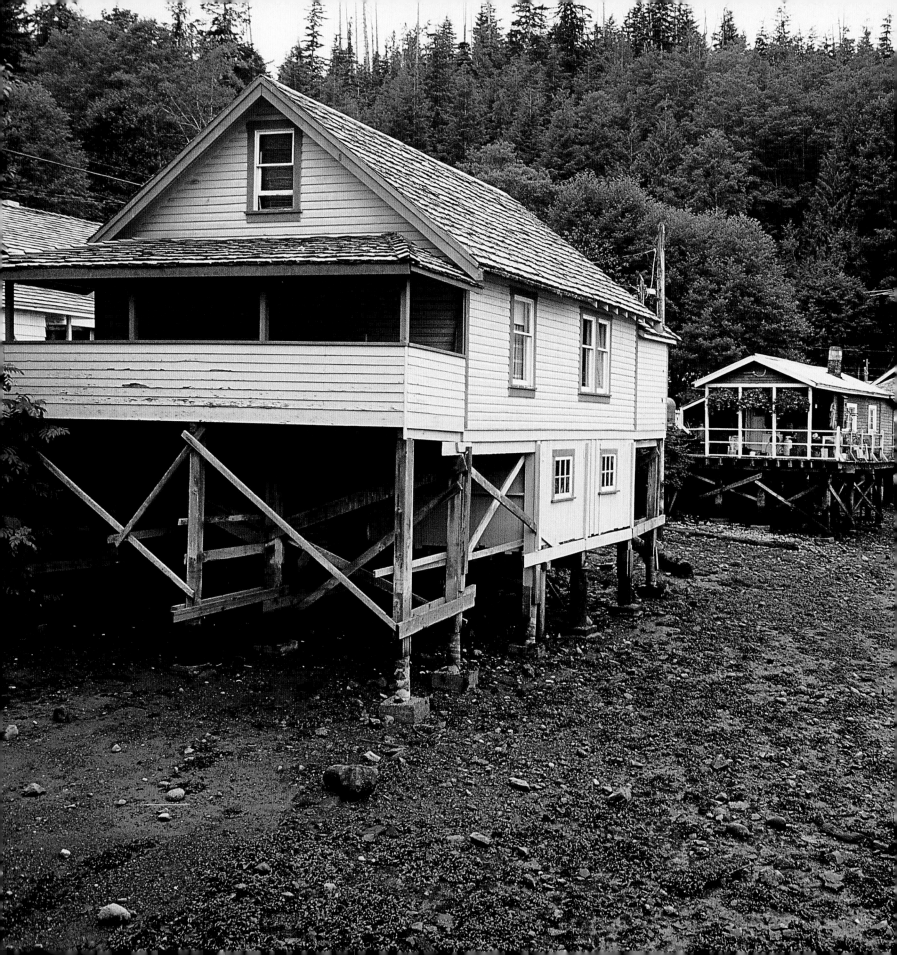

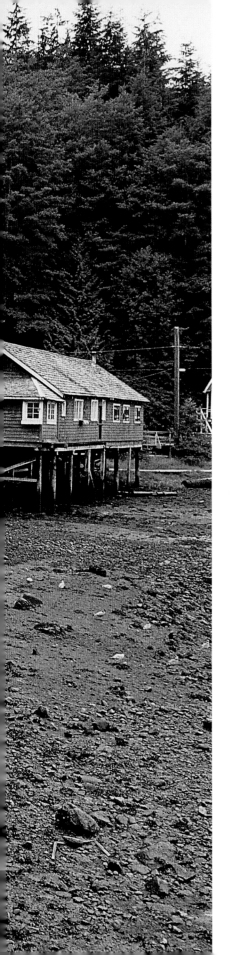

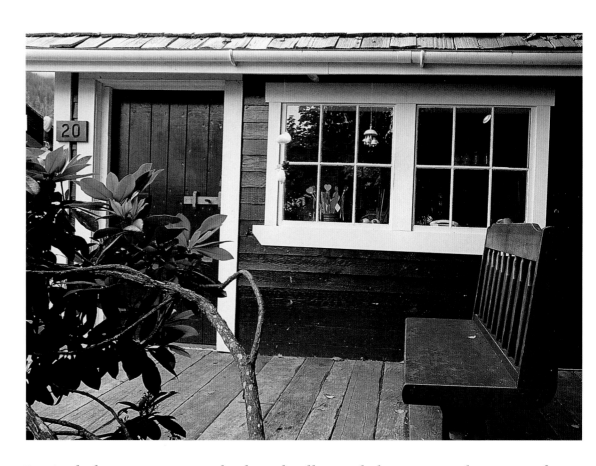

Lovingly kept cottages, cedar boardwalks, and shops remind visitors of a time when Telegraph Cove was the northern terminus of a coastal telegraph line and a small mill community.

At low tide, the pilings supporting the historic buildings of Telegraph Cove are clearly visible. The village now has a permanent population of 15, though many people visit the area for whale watching and charter fishing excursions.

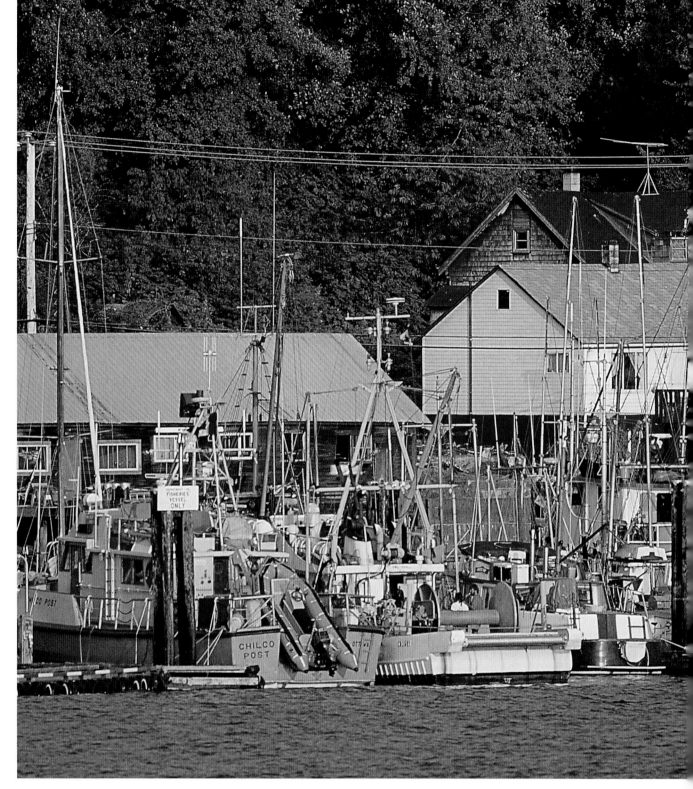

The village of Alert Bay is founded upon the fishing industry. Originally, this land was a summer settlement and food-gathering place for the local First Nations. In 1870, two entre-preneurs established a salmon saltery on the island and a cannery was built in 1881.

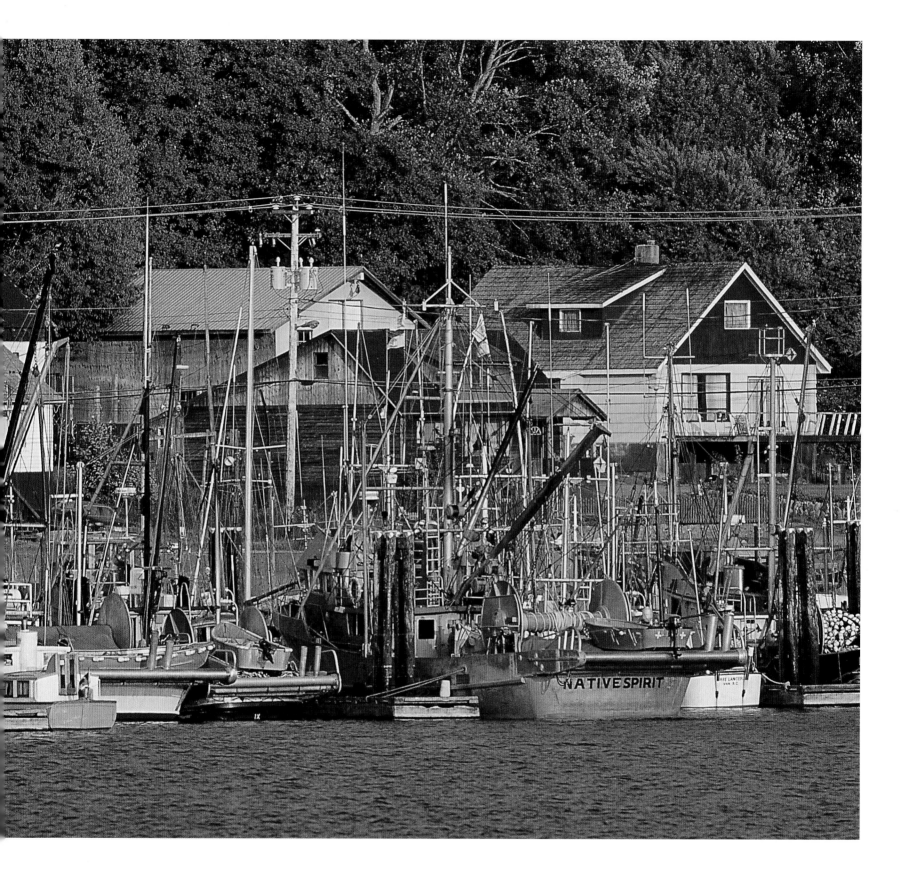

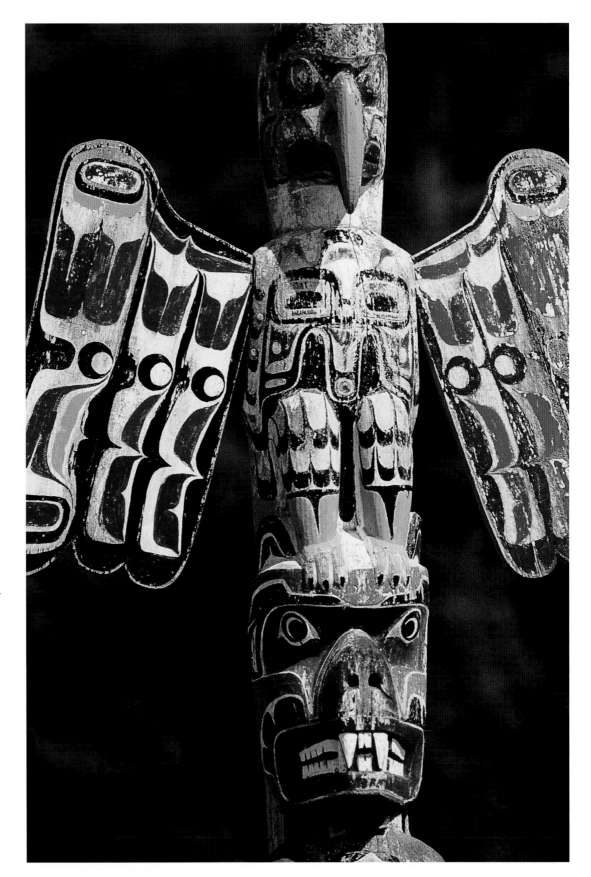

Alert Bay and Cormorant Island are part of the territory of the Kwakwaka'wakw First Nations. Some of the totem poles at the burial grounds here were carved in the 1800s and include the traditional motifs of grizzly bears, thunderbirds, ravens, and eagles. One of the tallest totem poles in the world also stands in Alert Bay.

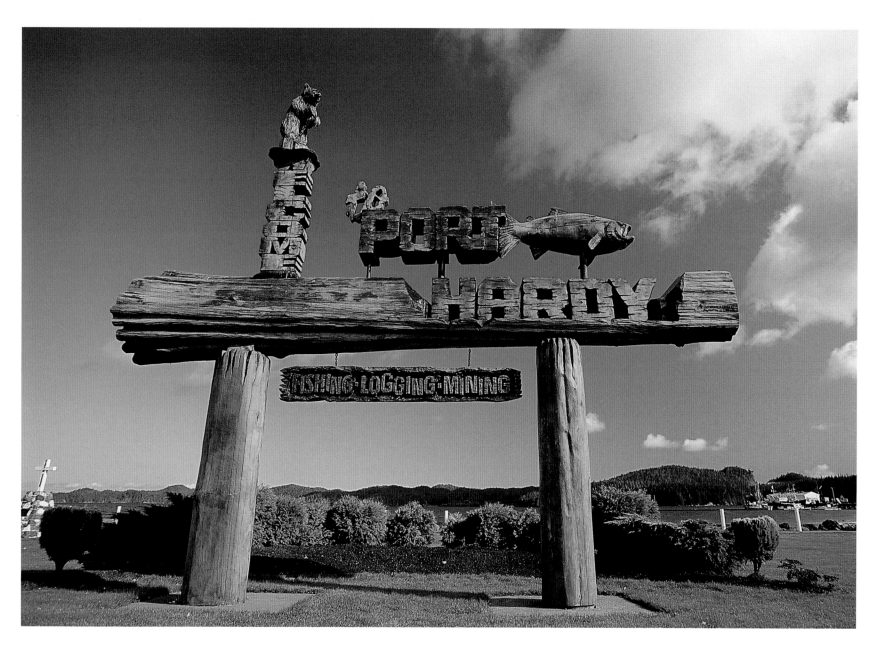

The Chamber of Commerce in Port Hardy offers a list of more than a hundred things to do in this small community, from scuba diving and berry picking to nature walks and sandcastle building. Filomi Days, held each July, is a celebration of the town's fishing, logging, and mining heritage.

Backpackers venture on a five- to eight-hour trek through Cape
Scott Provincial Park to reach the northern tip of the island. Along
the way, they glimpse the remains of an attempt by Danish settlers
in the 1890s to create a utopian community in the area.

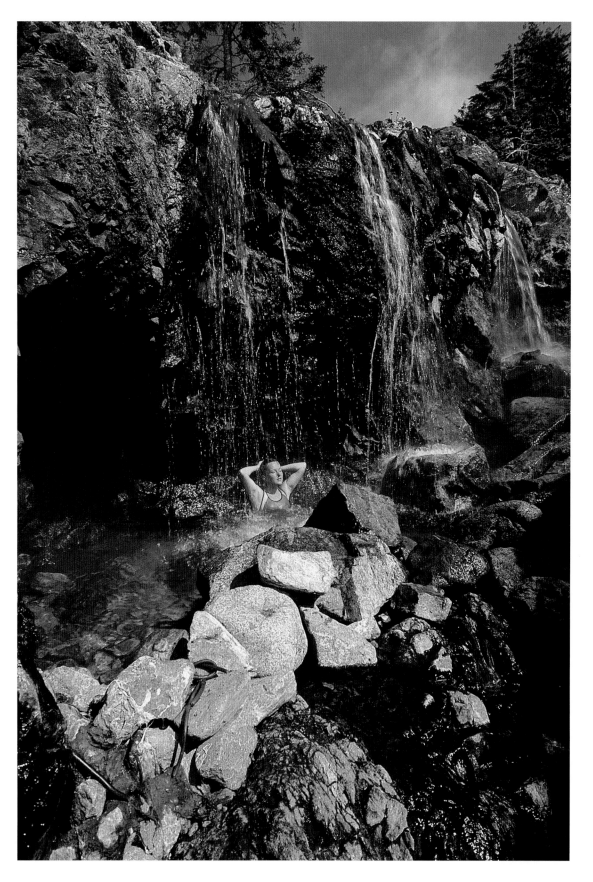

Accessible only by boat or floatplane, the mineral waters of Hot Springs Cove are the only hot springs on Vancouver Island. They are part of Maquinna Provincial Park, just north of Tofino.

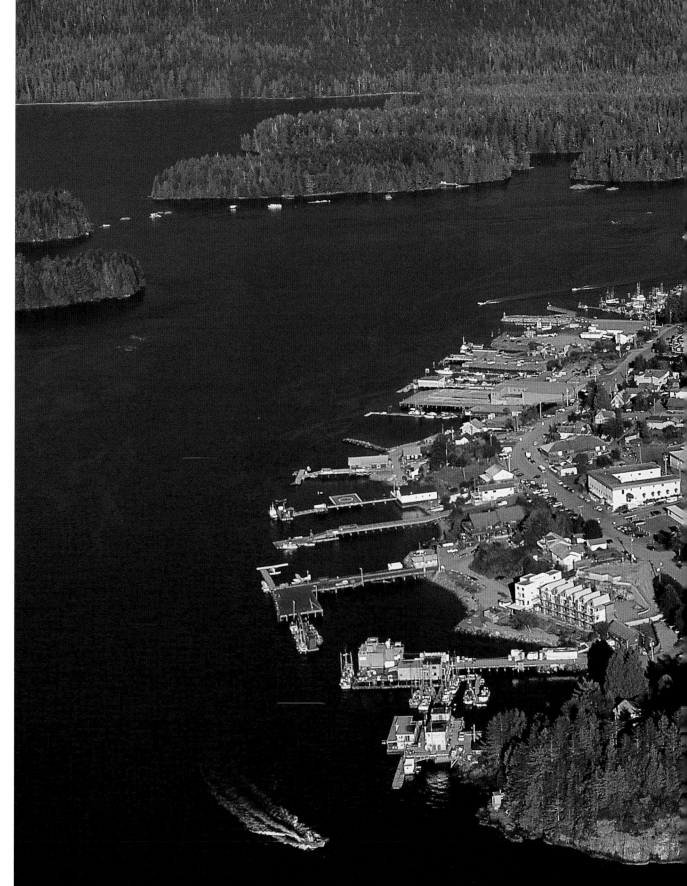

Just a short boat ride from Tofino, Meares Island is a pristine paradise of old-growth spruce, cedar, and hemlock. Throughout the 1990s, this area was a rallying point for environmentalists urging protection of Clayoquot Sound from clearcut logging.

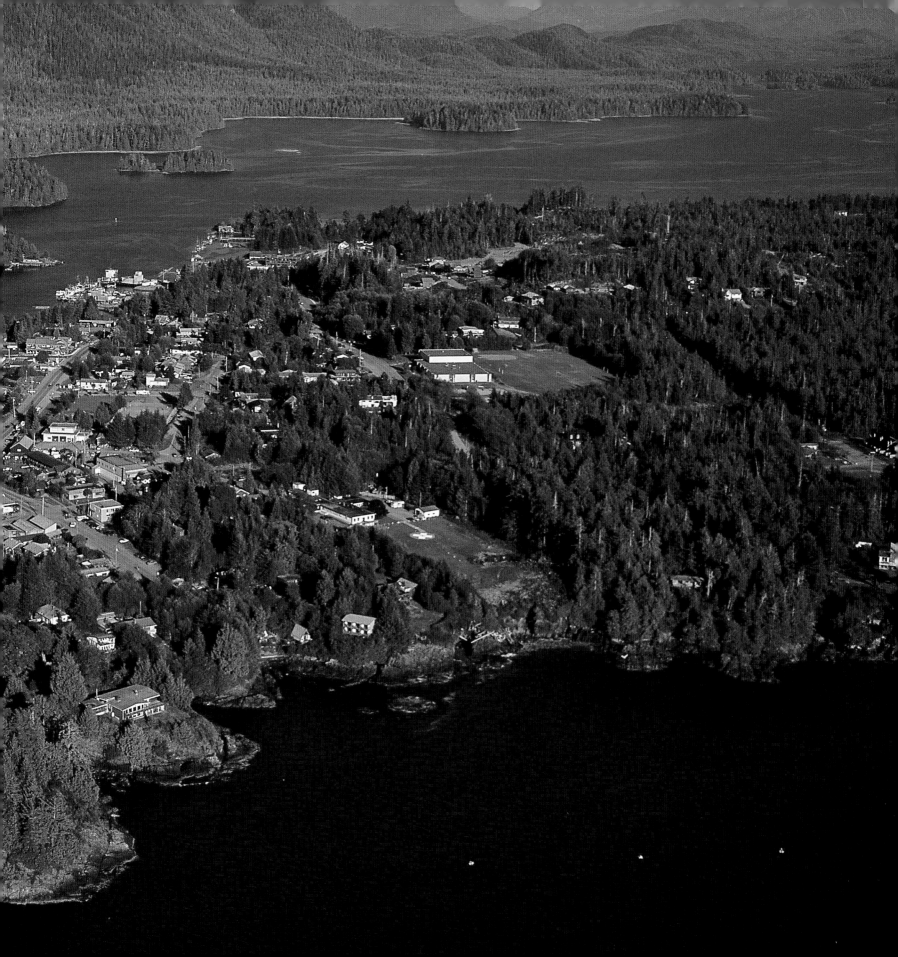

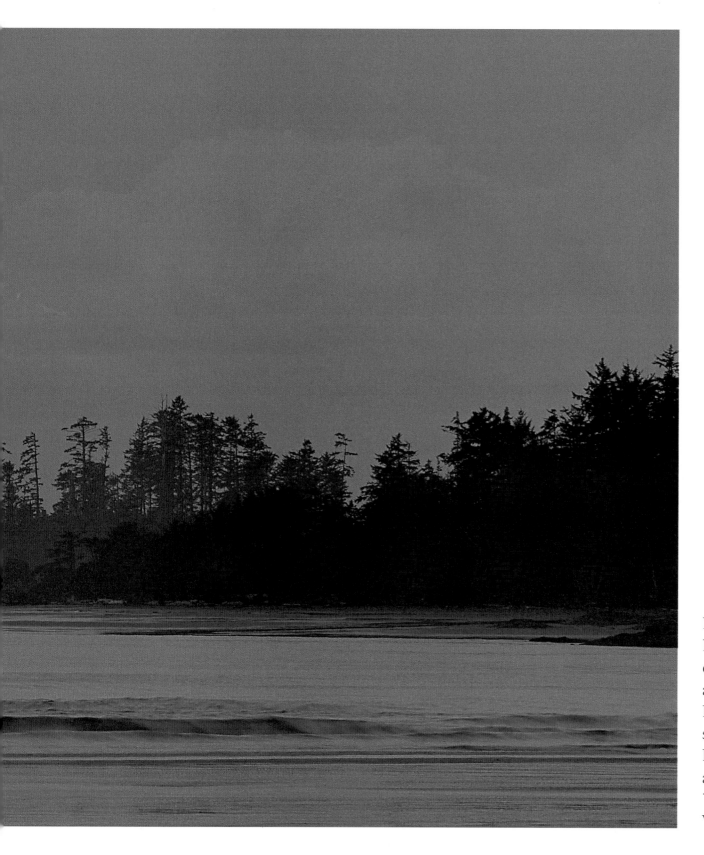

Pacific Rim National Park protects three distinct areas: the awesome expanse of Long Beach, the off-shore paradise of the Broken Group Islands, and the rugged 75-kilometre (47-mile) West Coast Trail.

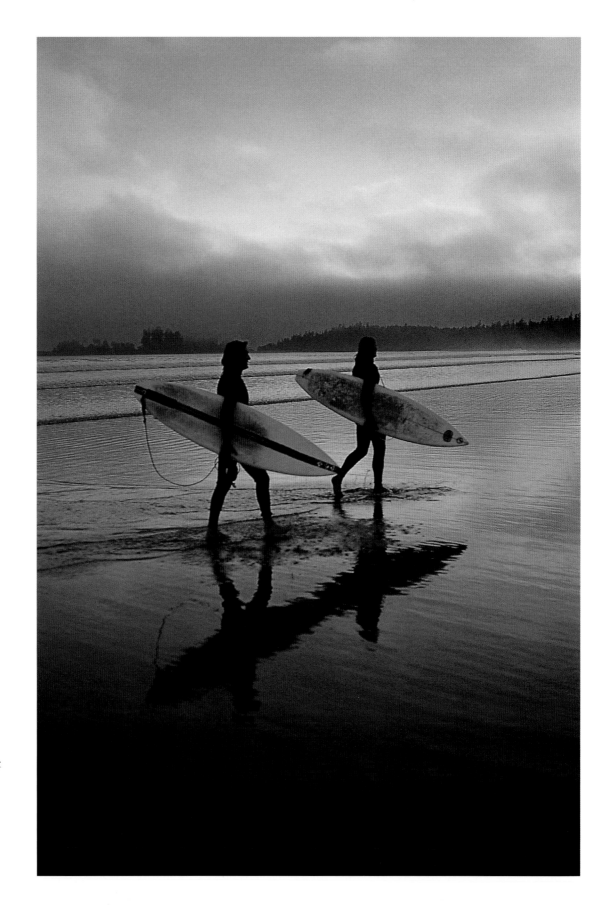

About 20,000 years ago, Long Beach and much of Vancouver Island was covered by a sheet of ice up to 300 metres (325 yards) thick. At the end of this most recent ice age, much of what is now Pacific Rim National Park was underwater.

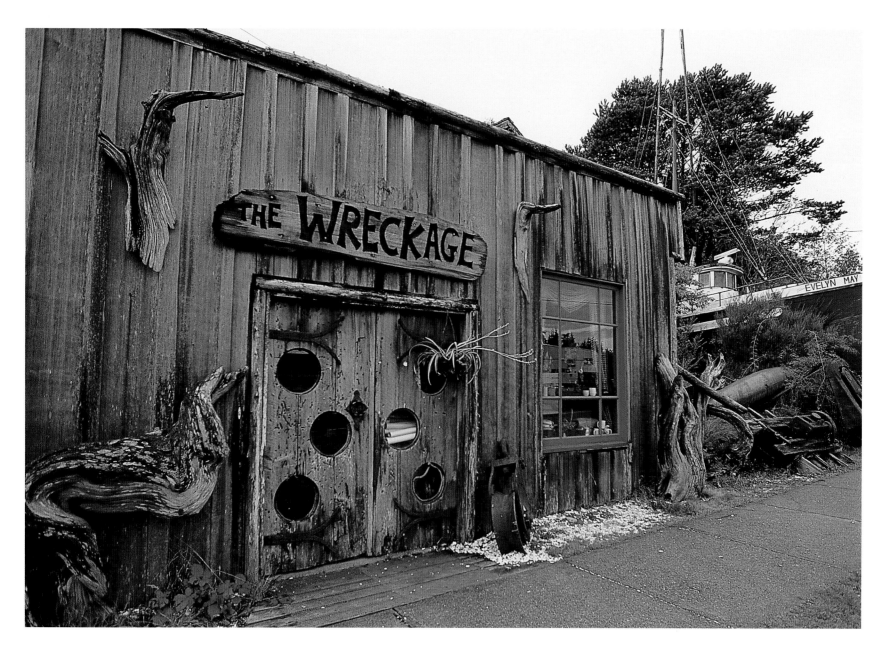

The population of Ucluelet doubles in the summer, when travellers flock to the community's shops and cafés and take advantage of the local whale watching, kayaking, and sport fishing opportunities.

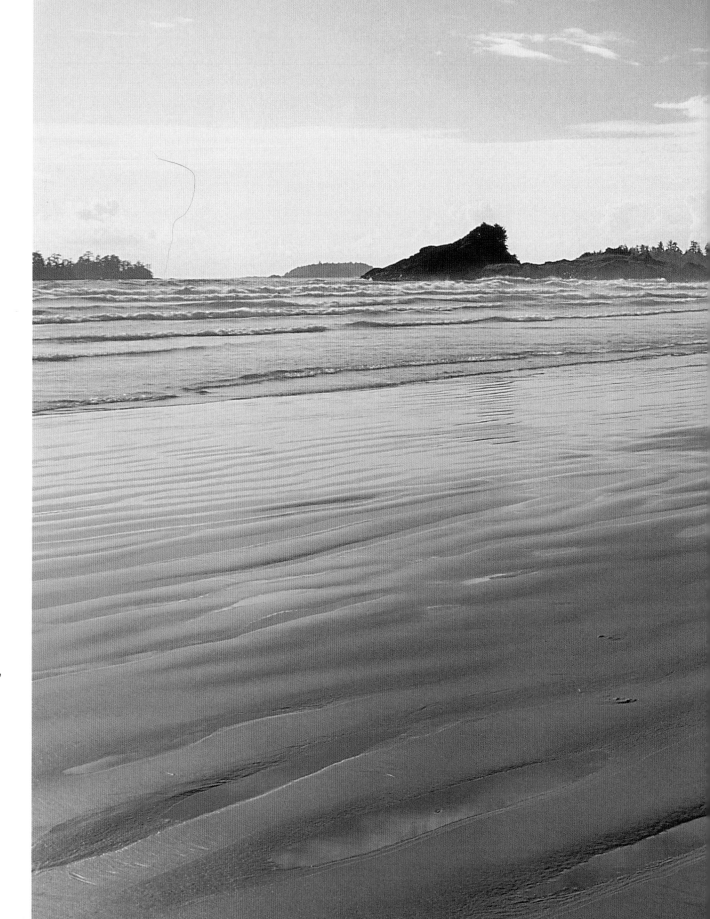

Huge waves batter the sands of Long Beach. In winter, these waves sweep sand from the beach, forming constantly changing bars off-shore. In spring and summer, a changed wave pattern deposits the sand back on the beach.

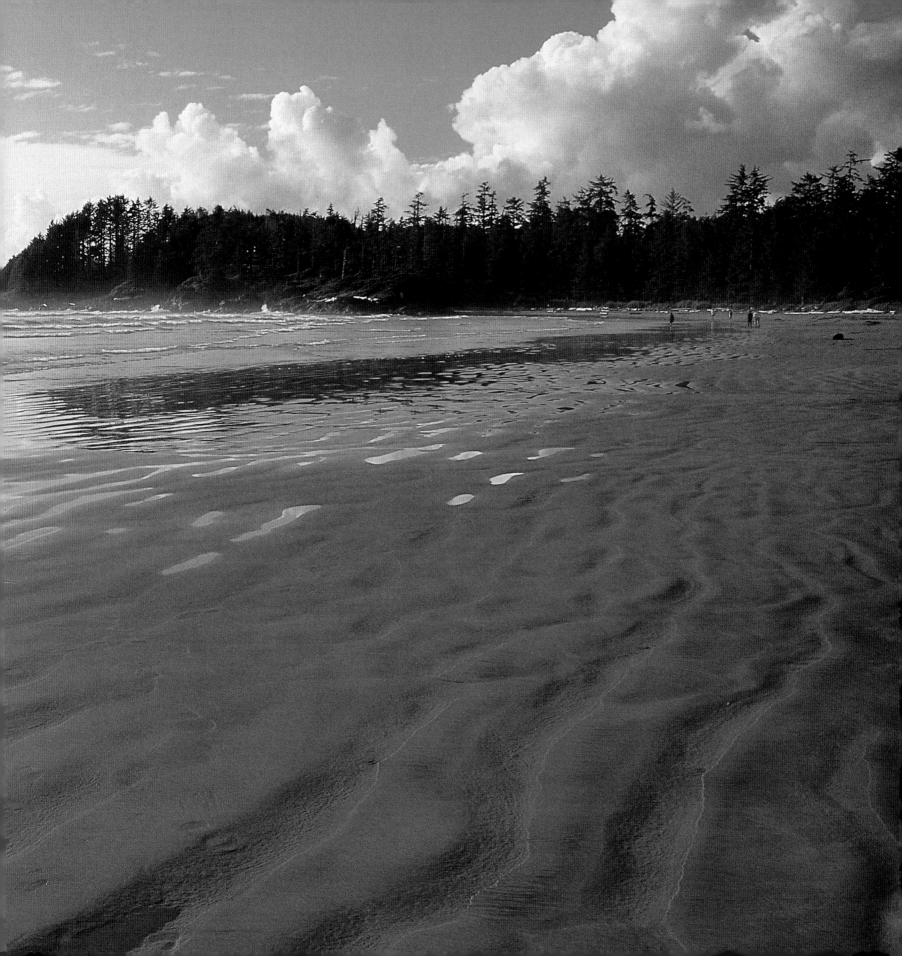

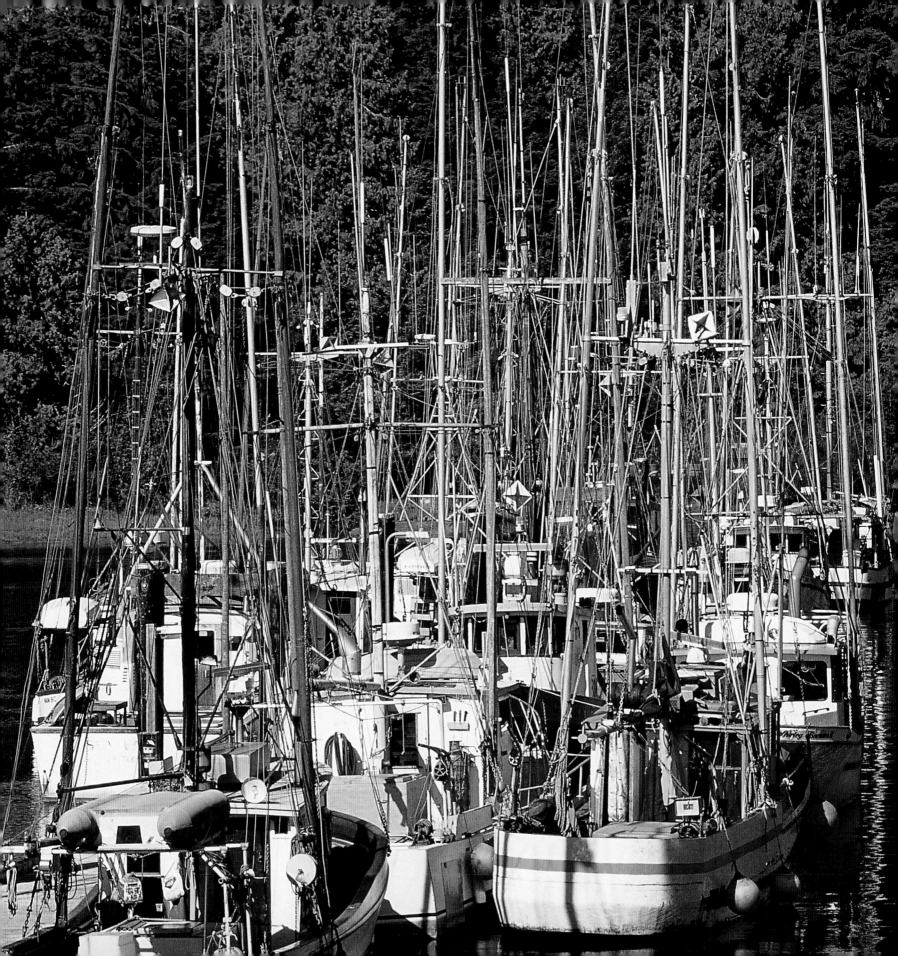

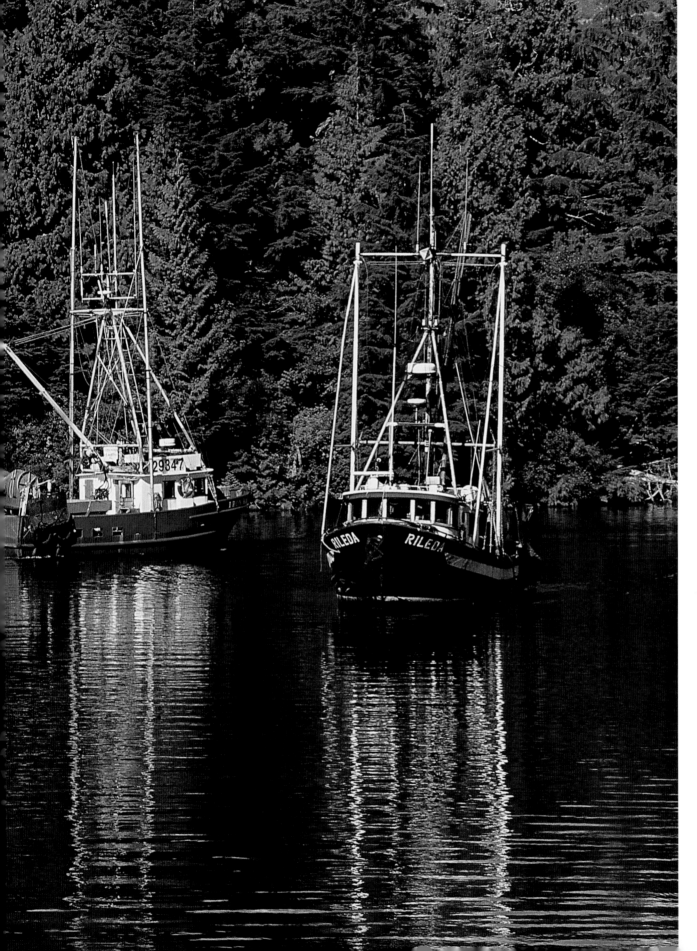

Ucluelet's harbour was a refuge for boaters long before commercial fishing began in the area. The town's name comes from the Nootka word meaning "people of the sheltered bay."

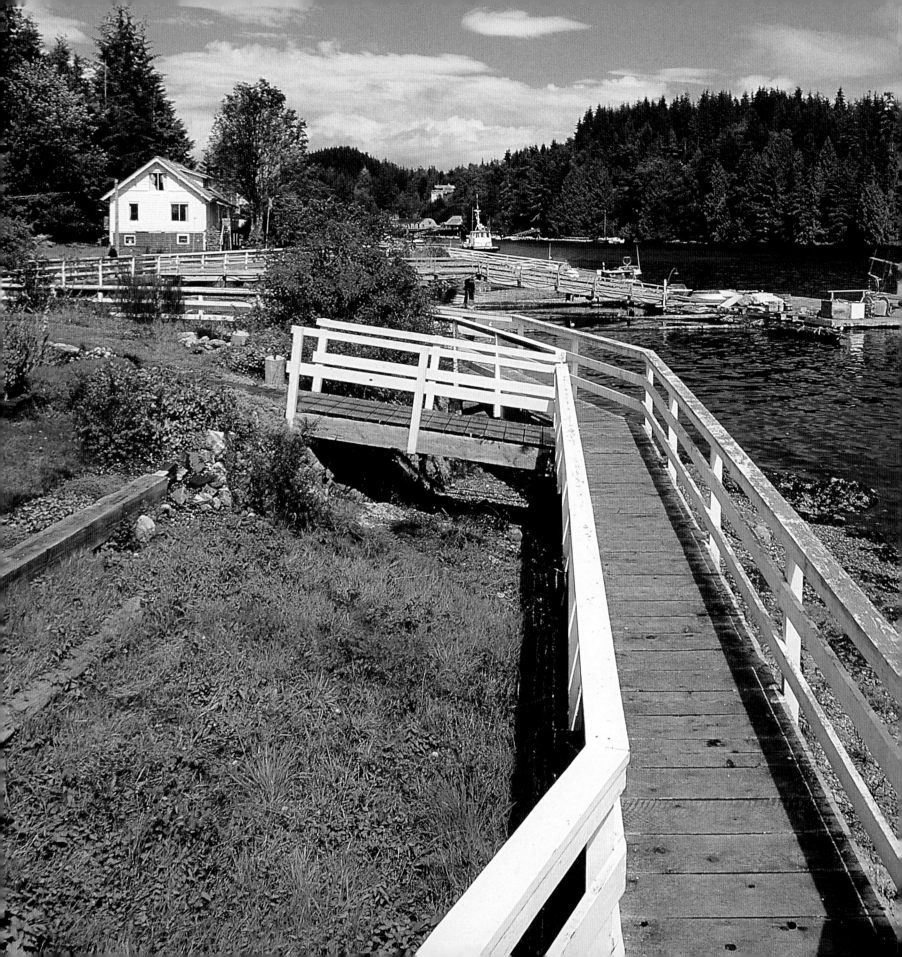

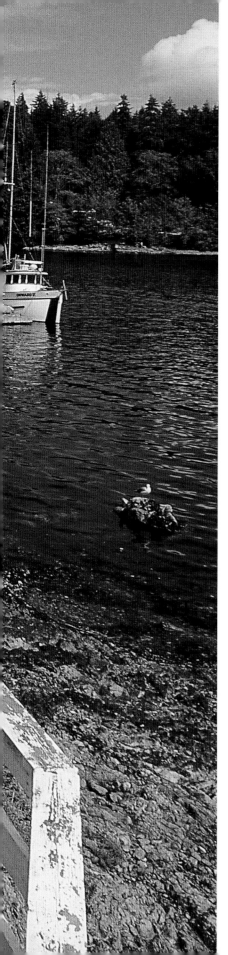

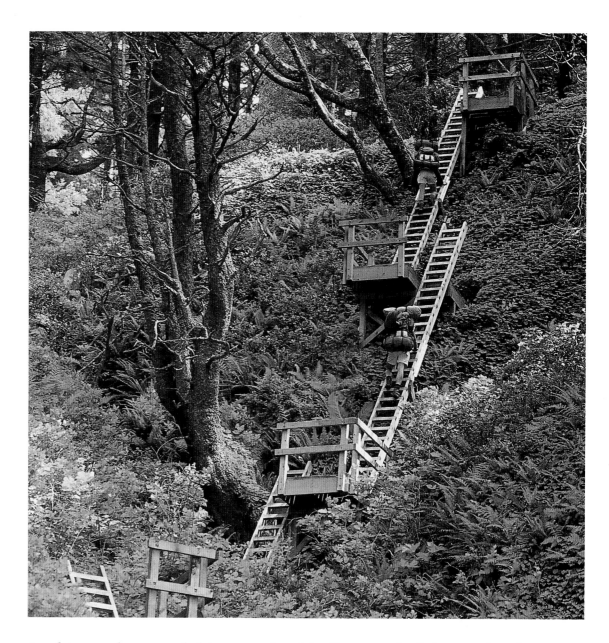

As shipwrecks earned this coast the title Graveyard of the Pacific, the government upgraded a telegraph trail to help lead victims to safety. In 1993, an improved route—now known as the West Coast Trail—became part of Pacific Rim National Park.

More than a century ago, Bamfield was a trans-Pacific cable station. A marine research station in the community now draws students from several Canadian universities.

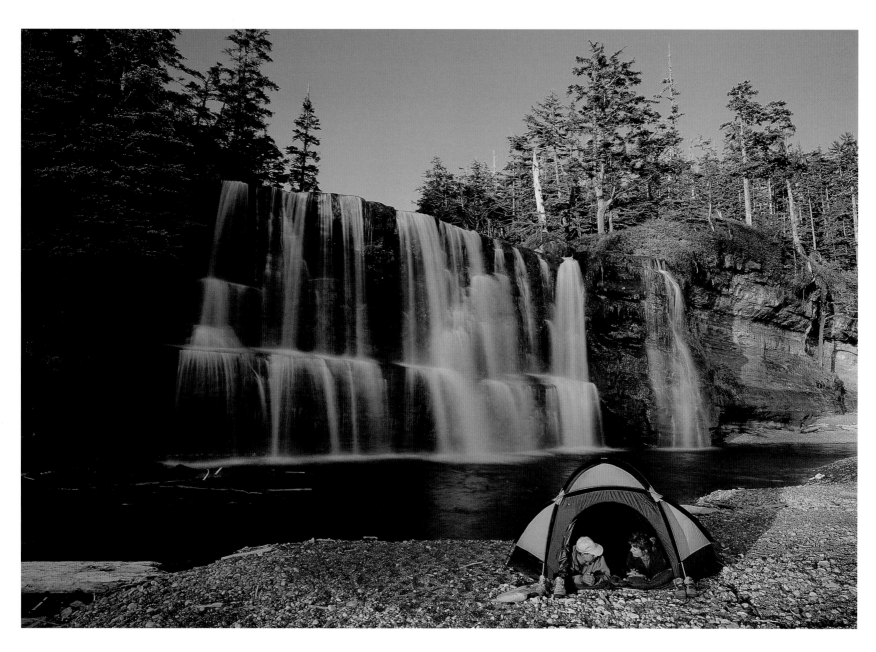

West Coast Trail hikers wander past caves, arches, tidal pools, some of Canada's largest spruce, hemlock and cedar, and the spectacular Tsusiat Falls—just a few of the attractions that lead hundreds of hardy adventurers to the trail each summer.

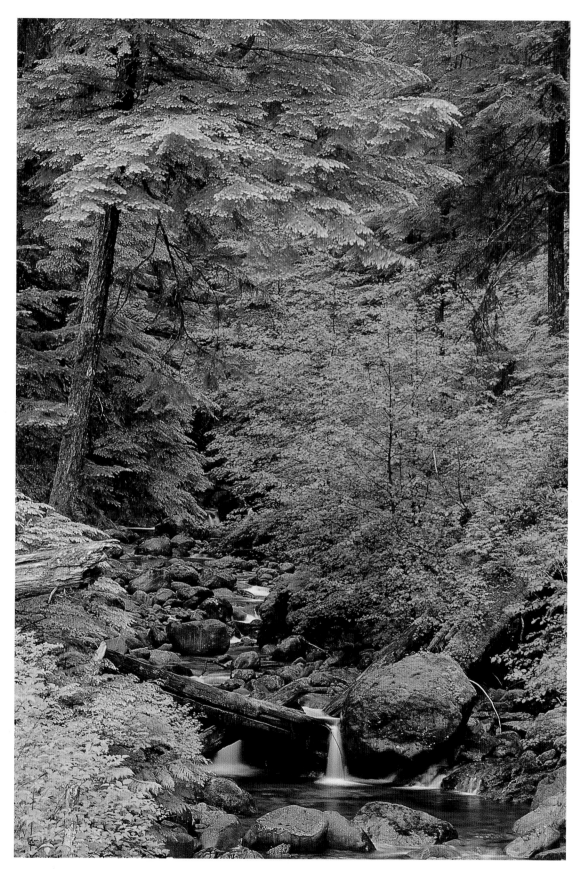

Carmanah Walbran Provincial Park preserves some of the most amazing old-growth forest on the island, including the Sitka spruce known as the "Carmanah giant," which towers 95 metres (310 feet) high and is thought to be the tallest Sitka spruce in the world.

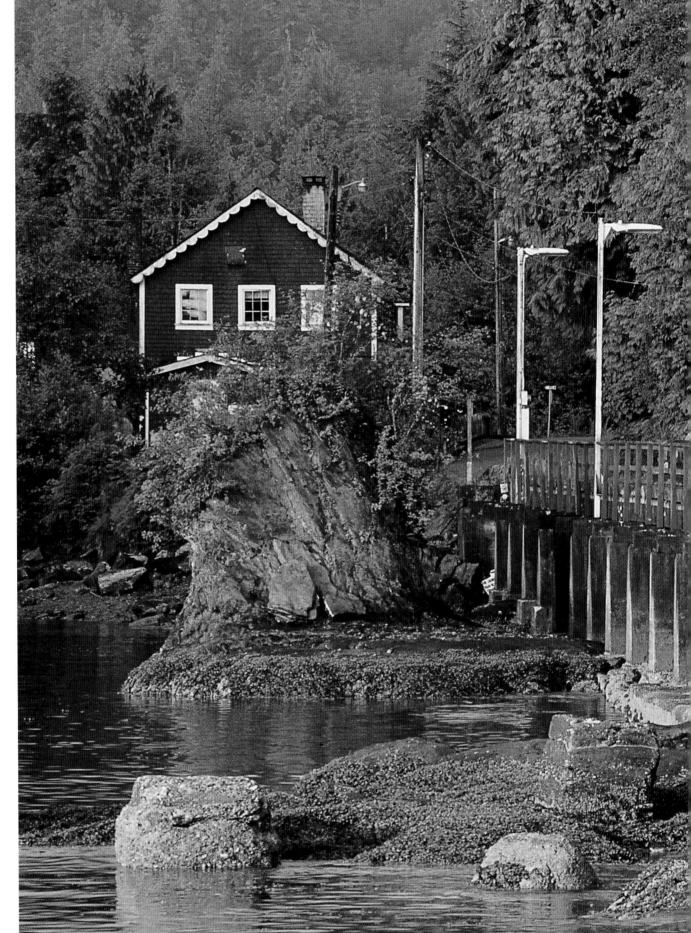

The government wharf in Port Renfrew and the pub nearby are usually populated by a combination of local residents and West Coast Trail backpackers, eager to be back in civilization.

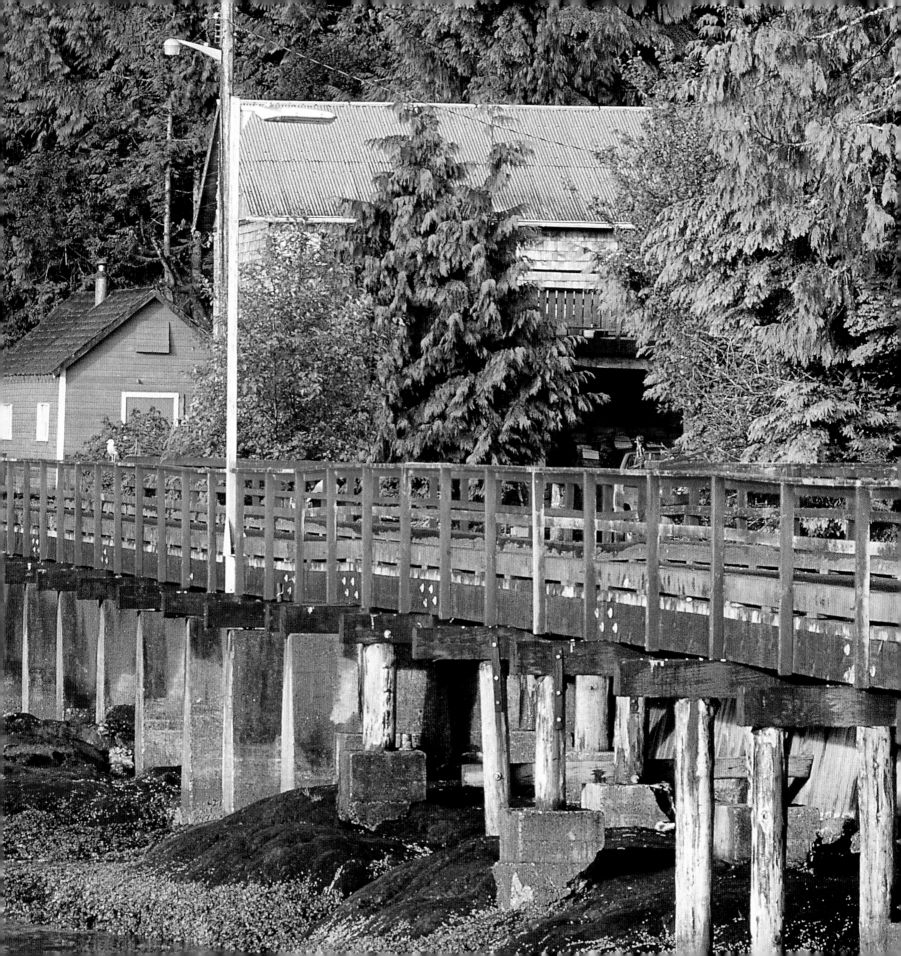

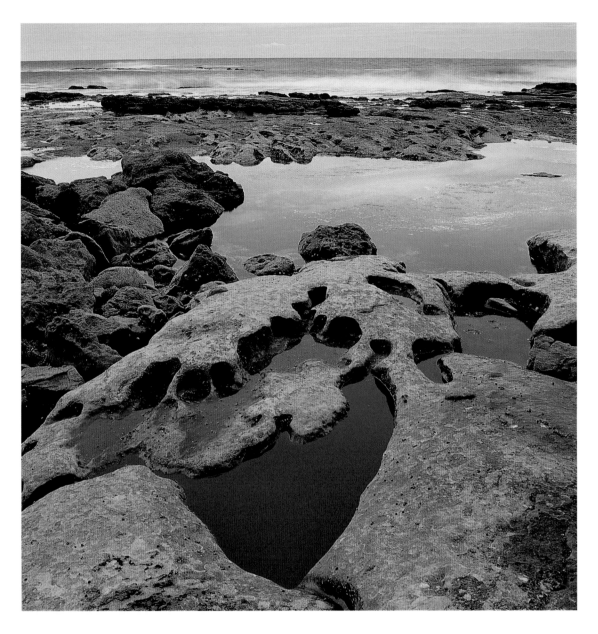

Researchers have identified more than 100 invertebrates and over 200 plant species at Botanical Beach Provincial Park. The plethora of marine life in the tide pools attracts shore birds, seals, and even black bears.

Due in part to the efforts of the Sierra Club, the Juan de Fuca Marine Trail was established in 1995. The 47-kilometre (29-mile) trail stretches from China Beach to Botanical Beach.

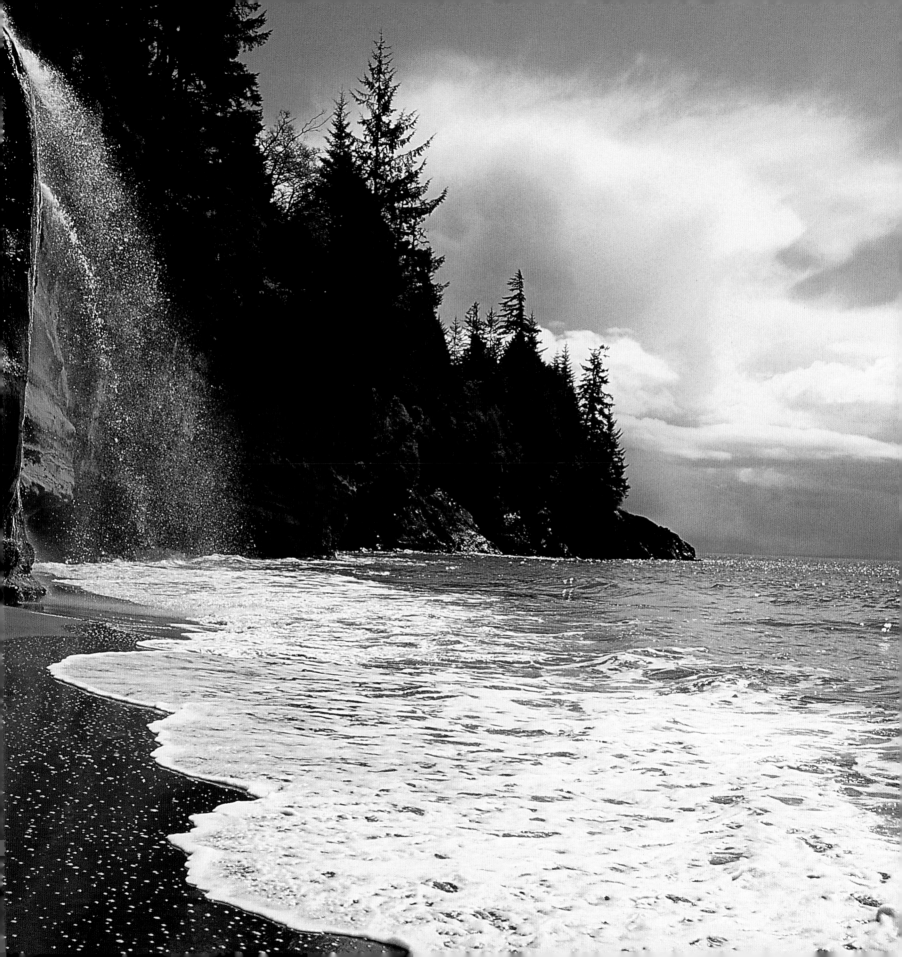

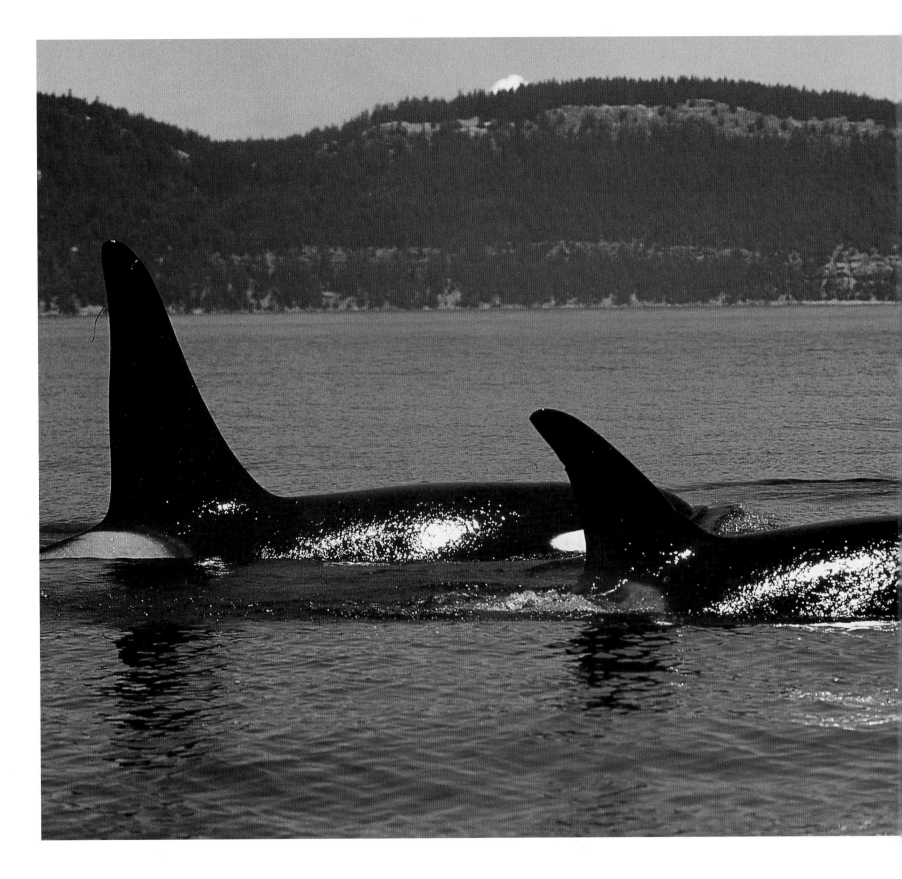

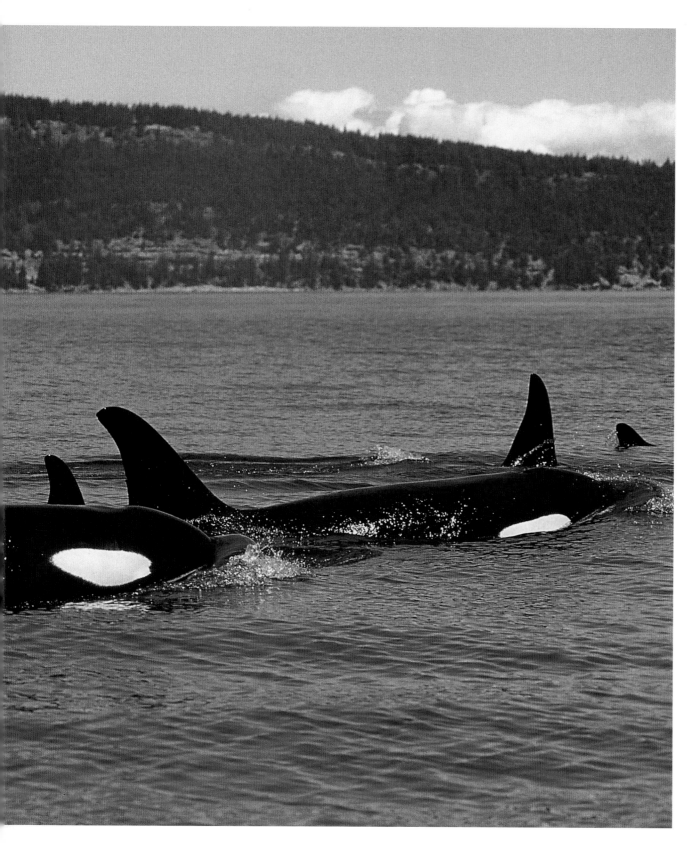

According to one native legend, Eagle was once alone in the sky and Whale alone in the ocean. One morning, Whale dove as deep as possible, then leapt above the water to mate with Eagle. Their offspring are the orcas, or killer whales.

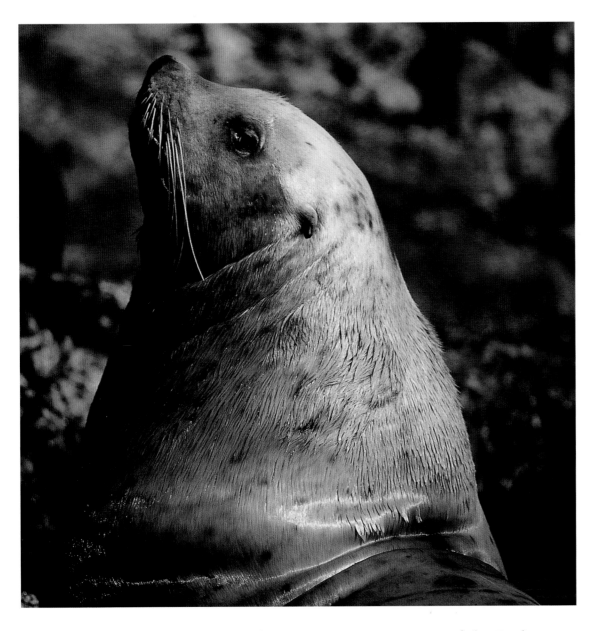

Both California and Steller's sea lions congregate on some of the Broken Group Islands, more than 100 small islands protected by Pacific Rim National Park.

Point No Point reaches 400 metres (440 yards) into the battering waves. It was named by those who first charted the coast, when they noticed the point was visible from one side, but from the other it appeared even with the rest of the shore.

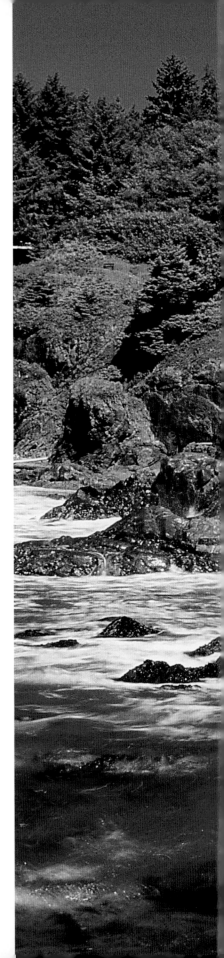

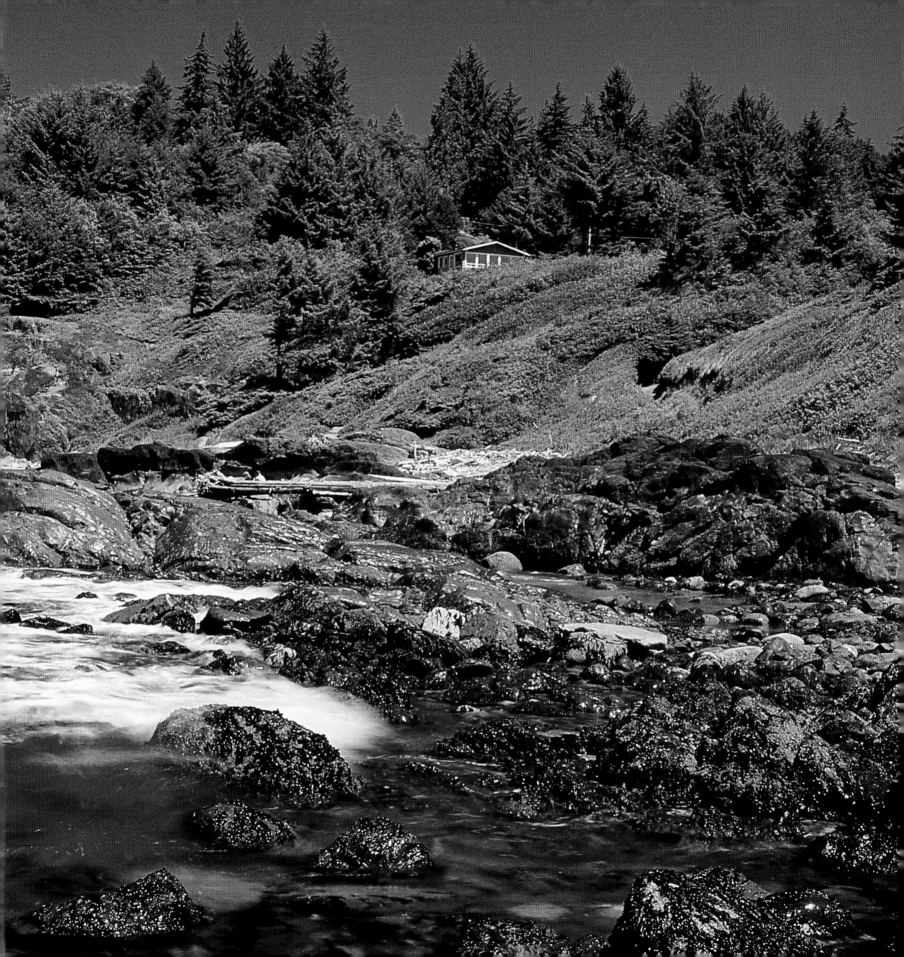

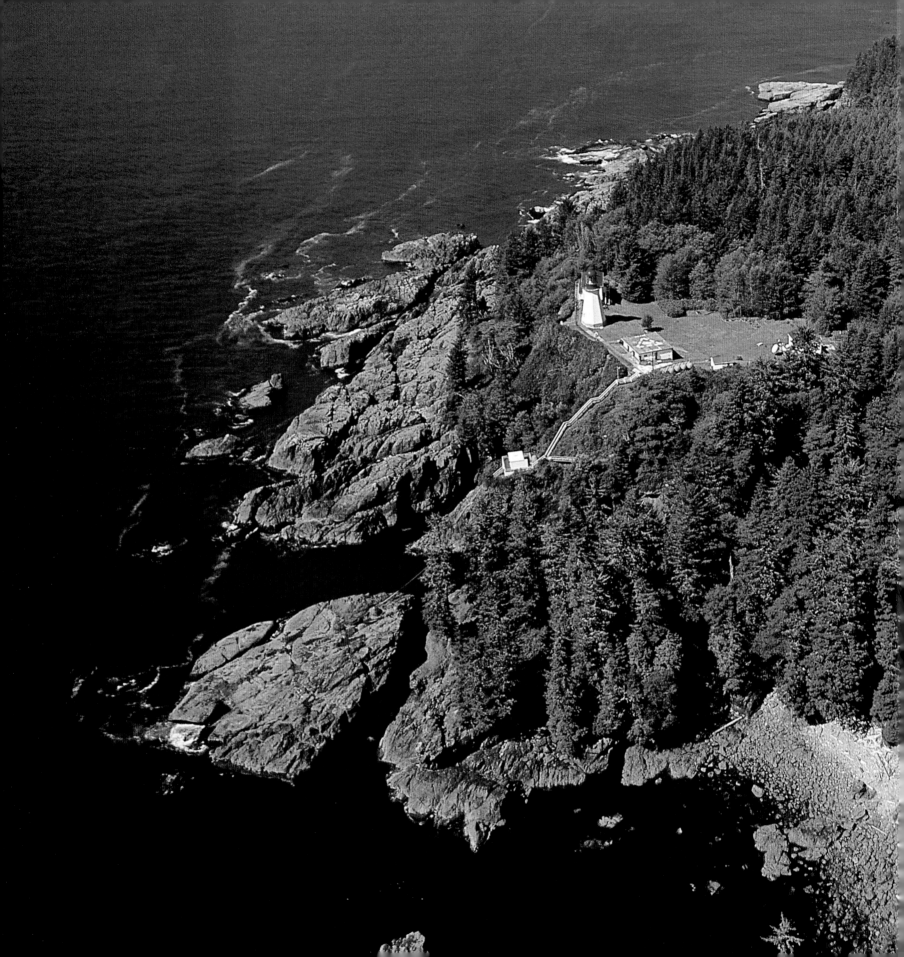

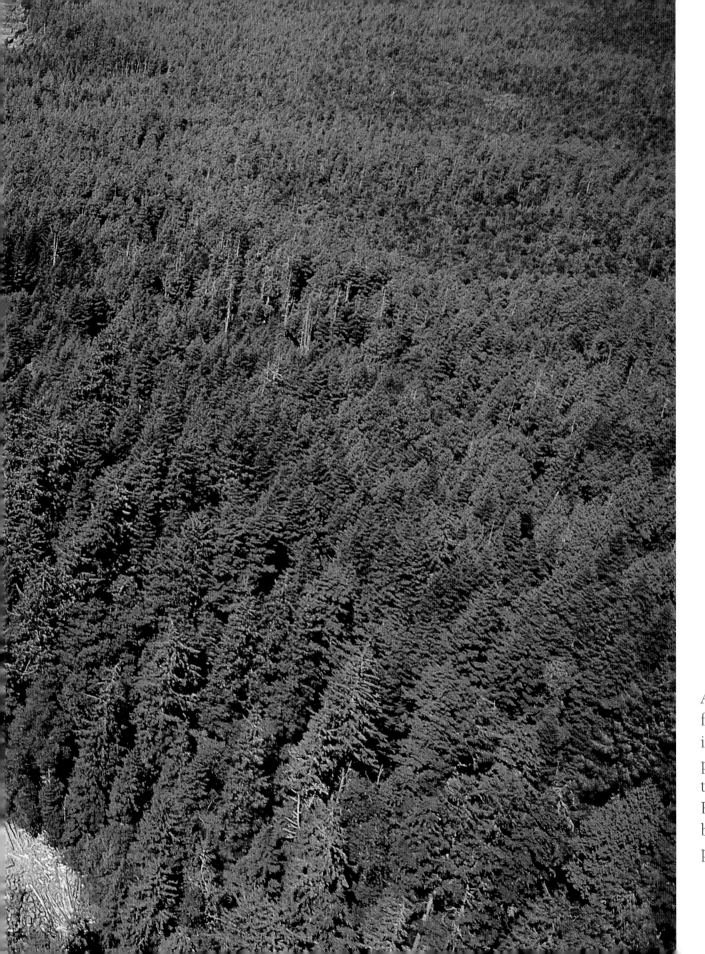

After the *Valencia* foundered nearby in 1906, killing 136 people, the construction of the Pachena Point Lighthouse began. It was completed in 1908.

Photo Credits